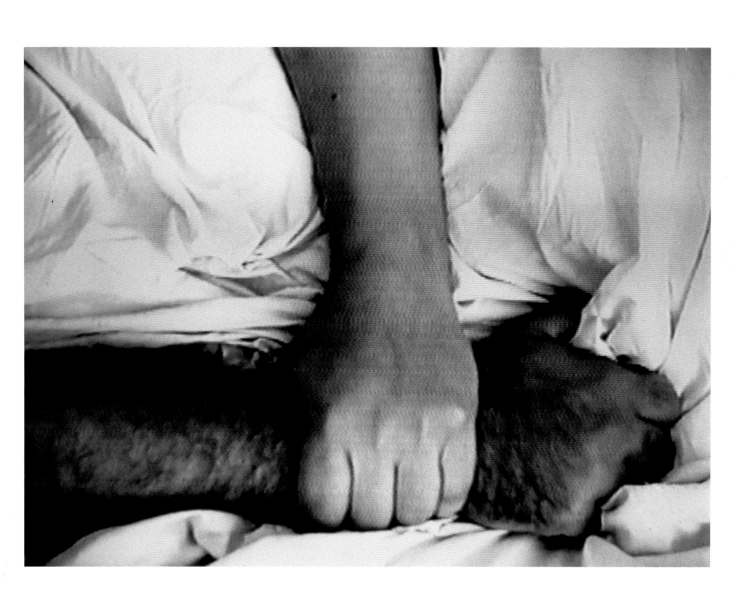

MODERN ARTISTS

First published 2004 by order of the Tate Trustees
by Tate Publishing, a division of Tate Enterprises Ltd,
Millbank, London SW1P 4RG
www.tate.org.uk

British Library Cataloguing in Publication Data
A catalogue record for this book is available from the
British Library
ISBN 1 85437 464 8 (pbk)
Distributed in the United States and Canada by
Harry N. Abrams, Inc., New York
Library of Congress Cataloging in Publication Data
Library of Congress Control Number: 2003101077
Designed by UNA (London) Designers
Printed in Singapore

Front cover (detail) and previous page:
A DIVIDED SELF II 1996 (fig.51)

Overleaf: LIST OF NAMES 1990–
Wall text
Dimensions variable
Installation view:
'Entr'Acte 3', Stedelijk van Abbemuseum, Eindhoven 1995
Collection Scottish National Galleries

Measurements of artworks are given in centimetres,
height before width, followed by inches in brackets.

Author's acknowledgements

Lisson Gallery, London and Gagosian Gallery, New York;
John Jervis, Katherine Rose and Sarah Tucker at Tate
Publishing for their patience and cooperation; Lewis Biggs
for his close and careful reading; Peter Baillie, Stuart Cross
and Faith Liddell at Dundee Contemporary Arts; Julian
Forrester, Kim Sweet, Sacha Craddock and Peter and Eileen
Jacobs at Cove Park for the valuable time and space; Mark
Currie, Kay Pallister, Bert Ross and, above all, Nathan Coley
and Douglas Gordon.

Artists's acknowledgements

Katrina, Anna, JGGG, Nato, KP, Pilar and Bert.

DG

DOUGLAS GORDON

Katrina M. Brown

Tate Publishing

JACK PIERSON
FRANCESCO BONOMO
ECKHARDT SCHNEIDER
CLARA URSITTI
LUCIA NOGUERA
MATT MULLICAN
PAOLO ROBALA
EDDIE BERG
JAKE CHAPMAN
MARK PIMLOTT
ROSS HUNTER
IAIN McGILL
JONATHON MONK
TOM CHAMBERS
DAVID THORPE
ROBERT SHEARER
DAVID FOY
ULRICH LOOCK
MARCUS GEIGER
NIKOLAS SCHAFFHAUSEN
KERRY BROUGHER
ANDREW TAYLOR
SUSAN KEALEY
EUART CORRIGAN
WILMA HOPKINS
JOSIE WALKER
TONY FRETTON
FRANK FIETZEK
TERRY BRAUN
HENRY JOHNSON
JOHN SAYERS
LEIGH FRENCH
TANYA STEPHAN
VEIT GORNER
GIJS STORK
DENNIS DAHLQUIST
WARREN NIESLUCHOWSKI
SALLY RAHMAN
ARTUR MIRANDA
MICK SCHRADER
LAUREN KELLY
NORA BROUGHER
ADAM PRIDEAUX
FRANCES CORRIAS
FRANCESCO CORRIAS
ANGELINE TACCINI
HELEN WOODS
IAN BEADLE
TRACY BEADLE
ALESSANDRO CORRIAS
FRANCESCA FIDANZA
FRANCESCA CROMBIE
ALICE LAHN
RENE LAHN
CHARLIE LEADER

JOHN PRIME
MARY BLACK
GORDON ADIE
DONALD McGHIE
SARAH WEATHERALL
ANGUS FAIRHURST
FRIEDERICH PETZEL
EVELYN IOLIANNO
MARGARET PHELPS
JIM LUSI
ALISTAIR McDONALD
SAM SCOFIELD
PAUL MAGUIRE
RICHARD GRIMES
ANNE RUSSELL
IAIN SLACK
ROGER CLARKE
MAMIE McDOUGALL
RUTH STIRLING
SALLY GOLDING
BEA VESZELY
HARALD SZEEMAN
URS FISCHER
MATTS LEIDERSTAM
MATTS STJERNSTEDT
SAM SAMORE
JAMIE BURROUGHS
GILLES PEYROULET
ERNST CARAMELLE
ANTONI ESTRANY
THOMAS KELLY
JANE WARRILOW
FREDERIC PEREZ
GARY HUME
ELIZABETH BEATON
DANIEL McLEAN
GIO MARCONI
HEIMO ZOBERNIG
ERIC SAMAKH
CERITH WYN EVANS
GITTE VILLESEN
GAVIN BROWN
JANICE McNAB
STEVE McQUEEN
TIM BLUM
BARRY BARKER
CHIARA BERTOLA-SERLINI
ERNST POPPEL
GOLDA MAAS
JOHN MUNDELL
BILL POTTS
ANGELA BROWN
PADDY KELLY
JEAN ROBERTSON
CLAIRE EARDIE
IRENE BRANSON
BERNADETTE OWENS

24 HOUR PSYCHO 1993 [1]
Video installation
Dimensions variable
Installation view: 'what have I done',
Hayward Gallery, London 2002
Collection Kunstmuseum,
Wolfsburg; Bernhard and Marie
Starkmann, London

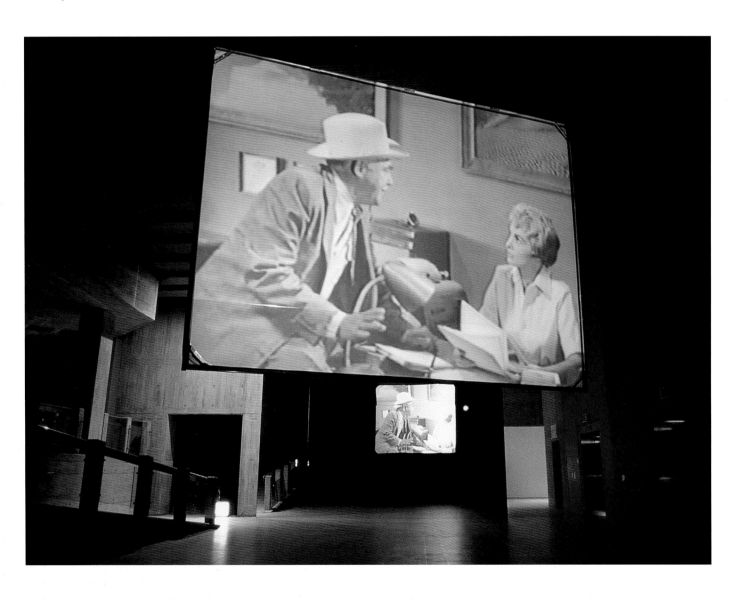

1

Dialogue is the primary motif of Douglas Gordon's work. It is fundamentally rooted in a desire for social exchange, a dialogue between artist and viewer, between individuals or opposing concepts. Out of this, he seeks to bring about a third, less finite position, generated in the space between the two, from which either extreme can be seen anew and in which the ground is uncertain. Reflecting this, both formally and conceptually, his works often feature two or more distinct points of view, perspectives that may appear irreconcilable: black and white, good and evil, remembering and forgetting, dark and light. His is a world full of opposites.

Just as the work seeks to animate a space between two positions, so it seeks to occupy a space between the viewer's – or receiver's – psyche and the physical space she or he inhabits. His work has consistently sought a kind of boundlessness, an ability to exist beyond the physical confines of the space in which it is encountered.

This texts charts the development of Douglas Gordon's practice from the early 1990s to the present, exploring the specific fusion of form and content that has characterised his work in a diverse range of media, including film, video, text, objects and photographs. Typical of his conception of how art can operate is his oft-cited remark that it is simply 'an excuse for a conversation'. He sees the artwork as a platform on which elements are brought into play to trigger broad associations and lead to an open-ended, discursive process: *I provide the board, the pieces and the dice, but you are the ones who have to play.*

Exemplifying a widespread readiness in contemporary visual art to incorporate existent elements from other disciplines, Gordon's works have extracted source material from its original context, fundamentally transforming the available interpretations and associations. His referents are repeatedly music, literature and film. He exploits music's ability to transcend physical boundaries, literature's ability to conjure the unreal from the imagination and film's fusion of visual and aural experience. From classic Hitchcock films to minor B-movies, from the Bible to an obscure nineteenth-century Scottish novel, his sources are diverse, but they have in common a thematic concern with the boundaries between good and evil, right and wrong, with examining the map of our moral behaviour.

What he does with this material, whatever its origin, is not just to render the familiar strange. He co-opts the web of cultural and social resonance that emanates from these existent works – the myths and stories, whether personal or collective, that have developed around them. It is the associative power of memory and imagination that gives them social significance. The films and books that he incorporates in his own similarly recount narratives, stories onto which individual interpretations, observations and fantasies are projected as they are processed into something meaningful to our understanding of the world. They come to exist in memory alongside our own real, lived experiences, some gaining increased power and significance over time, all part of the complex networks of information that guide our behaviour and beliefs. In co-opting material from non-art sources, Gordon's works seeks not a Pop confusion of high and low, but rather to explore the operation of memory in the process of recognition. What thoughts and ideas are triggered by the act of recalling the previously encountered? What, how and why do we remember? How does this then go to shape our personalities? It is the essential subjectivity of how we interpret experience that is his concern. One piece of music can, after all, have wholly different

MEANING AND LOCATION 1990 [2]
Wall text
Dimensions variable
Installation view: University College,
London 1990
Courtesy of the artist

associations for two individuals. A means of looking at the relationship between the individual and the collective, paralleled in the unique as opposed to the shared experience, is one of the ways in which many works operate. Blurring boundaries between such oppositions, opening up unimagined spaces in between things, avoiding certainty and introducing doubt are the desired effects.

Of all the media with which he works, it is perhaps an astute understanding of film that has shaped the physical make-up of much of his work to date. While he is undoubtedly interested in the (relative) mass appeal and dissemination of films, he deals with specific genres and types, myths and atmospheres. Two distinct characteristics can be found in the particular films with which he has chosen to work. Firstly, there are those films around which myths have developed, those known by reputation if not by encounter. Secondly, there are what might be described as psychological thrillers. Several are undoubtedly films predominantly viewed on television, in private and domestic settings, with what that implies about the way in which they are consumed and remembered.

Similarly, many of the films, books and pieces of music that have figured in his work of the past decade are probably better described as 'familiar' rather than as truly popular. While several are straight from the heart of the pop charts, others are sourced from the very fringes of any conceivable mainstream, verging on the positively sub-cultural.

Human psychology – the study of behaviour, and more specifically its collapse into disorder – has also been an enduring fascination, leading Gordon to the history of psychiatry, which has provided material for a number of works. Fascinated with the moment at which the normal becomes abnormal, the accepted

undesirable, he has often played with his own identity, using his image in a number of works over the years. Conscious of public desires and expectations regarding the artistic persona and the quest for the exceptional and the extraordinary, he partially, but never fully, reveals a self that may or may not be true.

Gordon's enduring fascination with language and an extensive interweaving of literary themes and devices is the basis for the concluding section of this book, which explores a particularly Scottish literary tradition on which Gordon has frequently and increasingly drawn. He himself is an inveterate story-teller, keen to take his listener into the experiences that lie in his memory and have helped shape his identity, to invite her/him into some part of his past. He has frequently employed language in his work as well as using context to contribute to the creation of understanding, and enjoys the slipperiness of meaning: *I always liked the idea that words, which are supposed to be concrete, when spoken by a different person at a different time can have a completely different meaning.*

This fascination with ambiguity and double-meaning is most apparent in one of Gordon's earliest works, the aptly titled *Meaning and Location* 1990 (fig. 2). A particularly significant piece first shown in London in 1990, towards the end of his post-graduate study at the Slade, this work exemplifies the sensitivity to site that has been a recurrent feature of his practice to date. Transposing a single sentence from its original context to another setting, rendered in simple but authoritative lettering, Gordon brought about an acutely heightened awareness of the context in which it was encountered. The chosen phrase is from the New Testament and has been the source of much debate concerning the correct positioning of a comma. Gordon applied this text in its two versions

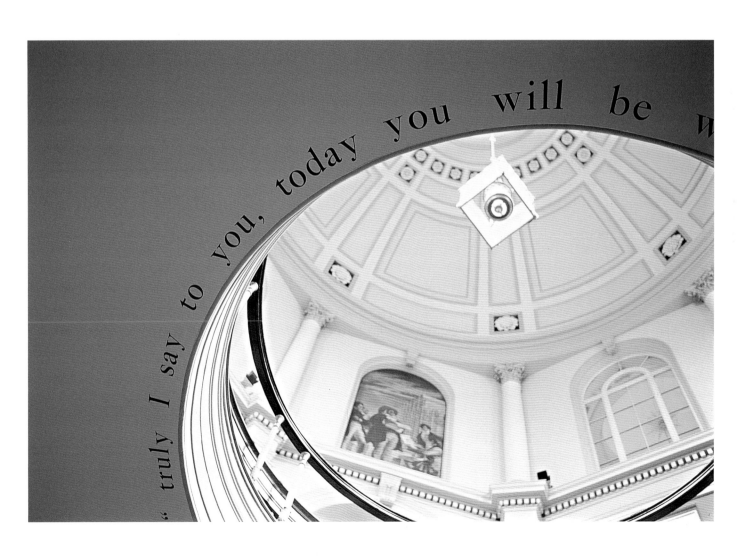

... truly I say to you, today you will be w

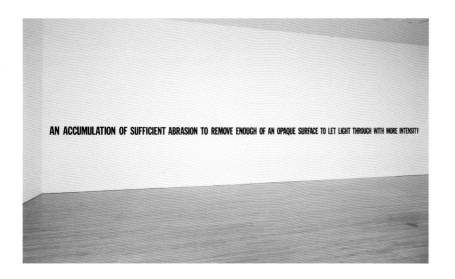

Lawrence Weiner
AN ACCUMULATION OF SUFFICIENT
ABRASION TO REMOVE ENOUGH OF
AN OPAQUE SURFACE TO LET LIGHT
THROUGH WITH MORE INTENSITY
1981 [3]
Language and the materials referred to
Dimensions variable
The Museum of Contemporary Art,
Los Angeles. Gift of Eileen and Peter
Norton, Santa Monica, California
Courtesy of the artist

around the edge of an aperture in a ceiling in University College, London. The text, attributed to Jesus on the cross and supposedly spoken to one of the thieves who is said to have hung beside him, reads: 'Truly I say to you today, you shall be with me in paradise' or, alternatively, 'Truly I say to you, today you shall be with me in paradise'. The simple shifting of the comma has implications as to the precise moment at which the righteous soul might ascend to heaven, the latter implying that it is immediately after death. Life and death, heaven and hell, right and wrong, fact and fiction – so many of the oppositional pairings that recur throughout Gordon's later work are introduced with this single phrase.

This and other text-based works recall much early Conceptual art of the late 1960s and 1970s, in which the form taken by the work may only be a few words, the idea privileged over the object, the process over the product. They undoubtedly share a desire to strip back, to present the artwork solely in terms of its fundamental components of thought and communication. The similarity is, however, only skin-deep, a knowing reference in Gordon's work rather than a guiding principle. For, where the language that appears in works by Lawrence Weiner (fig.3), Robert Barry and others sought a neutral, objective tone, describing an object or an action, Gordon's language is quite the opposite, tending rather to highlight the personal, foregrounding subjectivity and focusing on the existence of doubt and ambiguity. Compare, for example, the origins and implications of the texts used in *Meaning and Location* with those of a typical work by Barry, his *Marcuse Piece* of 1970–1 in which the following phrase was written in pencil at several points on gallery walls: 'Some places to which we can come, and for a while, "be free to think about what we are going to do" (Marcuse)'.

While the material form of Gordon's text-based pieces is similar to Barry's and others' in terms of its simplicity and absence of any image or object, they embrace a more complex sense of physicality, relying on an understanding of the viewer's relationship to the site and his / her behaviour within it. In this respect they are perhaps more akin to a Minimalist reduction of forms and interest in the viewer's physical co-existence and corporeal engagement with the artwork. With undeniable aesthetic and strategic references to both Conceptual and Minimal art, Gordon's is nonetheless fundamentally a socially rooted practice, his enduring fascination with language evidence of his concern with how we communicate and how meaning and, by association, identity are construed. The texts become a bridge offering a connection between viewer and site, the impact of the work existing in the coming together of the two in the viewer's mind. Emphasising this relational aspect, Gordon sets up a connection between subject and object, typically in the presence of an 'I' and a 'you' in the chosen text.

So much of the response to *Meaning and Location* stems from the specific context. Looking up to read the text, one could see the college library through the aperture. As one of the first secular educational establishments, and one of the first colleges to admit both female and Jewish students, its library extraordinarily contains no theological texts. Gordon's work played both specifically on this history and more generally on the perception of the library as a source of learning, knowledge and truth, but introduced the possibility of doubt, double-meaning and misunderstandings or alternative interpretations, even in such a site and such a text. The text is written in a typeface that has become a signature style. Bembo is a serif font associated with the printed page and

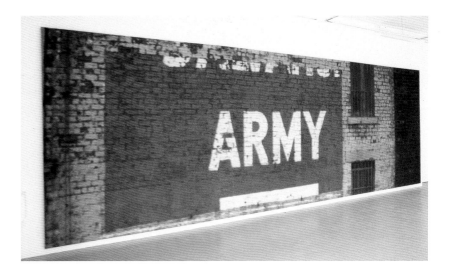

consequently with both authority and dissemination. In its reference to the Bible, historically a prime source for metaphors and allegories about human morality, *Meaning and Location* indicates some of Gordon's enduring concerns, not least language and his exploration of the ways in which it can be undermined, its original meaning cast in doubt. The presence of two distinct meanings in one phrase points to a use of splitting and doubling that is later manifest primarily in his video works.

Gordon has often attributed this sensitivity to context and readiness to engage with the specific metaphoric resonance or the physical make-up of the site to his years of study at Glasgow School of Art. Here he was part of a department, led by David Harding, in which students were encouraged to make work for non-gallery spaces and to consider 'context as 50 per cent of the work'. It is an approach that can be seen in a collaborative work Gordon made with fellow student Roderick Buchanan, in Belfast in 1991: a large photograph of the gable end of an old hostel in Glasgow, where the removal of a billboard had revealed the remains of an earlier sign. What must once have read 'SALVATION ARMY' was partly obliterated, leaving only the word 'ARMY' fully legible. Gordon and Buchanan transferred the image to a large banner and installed it on the back wall of the Orpheus Gallery in Belfast, where it was visible from the street. The work, entitled *London Road* 1991 (fig.4) (the location of the Glasgow hostel) used a simple strategy to expose the particularly loaded and politicised context of Belfast.

Whatever the percentages, Gordon has undoubtedly maintained an awareness of the contribution made by the conditions that surround the work, often incorporating elements of architecture in his specifications for the installation of pieces –

colour, size or shape of room, quality of light and so on. Several later works are happy to be prompted by context without being entirely reliant on or defined by it.

The concept of language as a blunt instrument rather than a refined tool recurs through many of Gordon's texts. It is the basis of his citation in a work from 1992 of the famous scene from Goethe's *Faust* in which Faust attempts to translate the Bible. Gordon's work (fig.5) is a small blue neon sign that reads 'Faust 1224 – 1237', referring to the following lines:

'Tis writ, 'In the beginning was the Word.'
I pause to wonder what is here inferred.
The Word I cannot set supremely high:
A new translation I will try.
I read, if by the spirit I am taught,
This sense: 'In the beginning was the Thought.'
This opening I need to weigh again,
Or sense may suffer from a hasty pen.
Does Thought create, and work, and rule the hour?
'Twere best: 'In the beginning was the Power.'
Yet, while the pen is urged with willing fingers,
A sense of doubt and hesitancy lingers.
The spirit comes to guide me in my need,
I write, 'In the beginning was the Deed.'

Faust is tormented by the problem, until he is visited by Mephistopheles, with whom he eventually concludes a pact. It is one of the world's most enduring, classic tales of good and evil, and inevitable material for Gordon.

A further text-based work of the same period saw Gordon decorate the dome of the central room in the Serpentine Gallery with a bold splash of blue paint and the words 'We Are Evil', also written in Bembo. Read in conjunction with the work's title, *Above All Else . . .* 1991 (fig.6), the phrase had Biblical connotations,

FAUST 1992 [5]
Neon
15 x 175 (5 7/8 x 68 7/8)
Courtesy of the artist

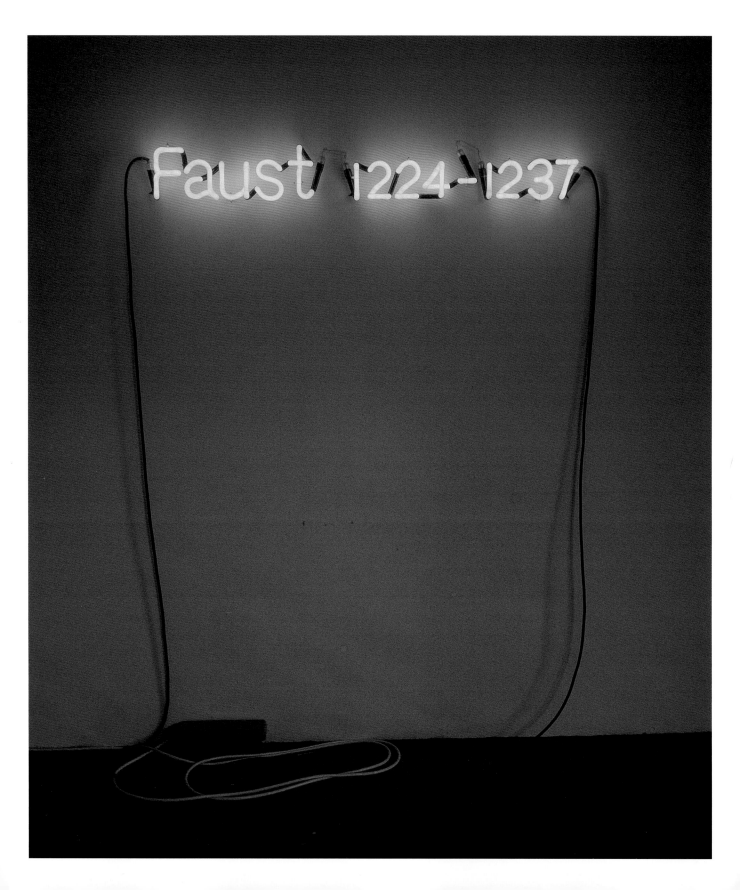

FAUST 1992 [5]
Neon
15 x 175 (5 7/8 x 68 7/8)
Courtesy of the artist

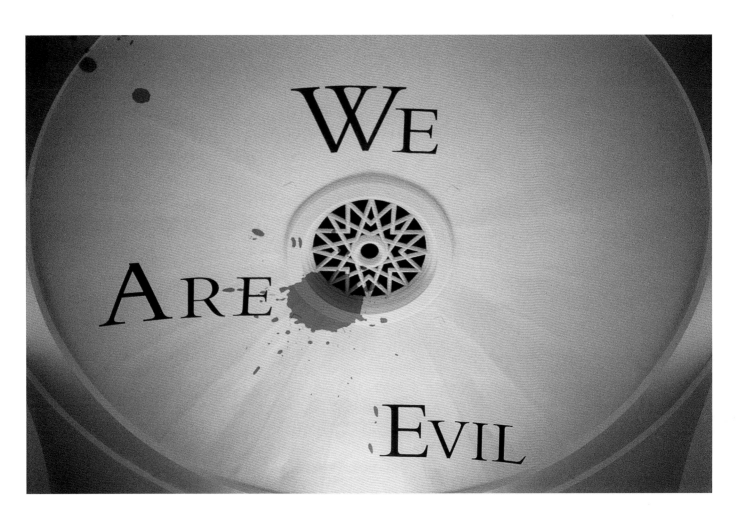

ABOVE ALL ELSE . . . 1991 [6]
Wall text
Dimensions variable
Installation view: 'Barclays Young
Artist Award', Serpentine Gallery,
London 1991
Weltkunst Collection, London

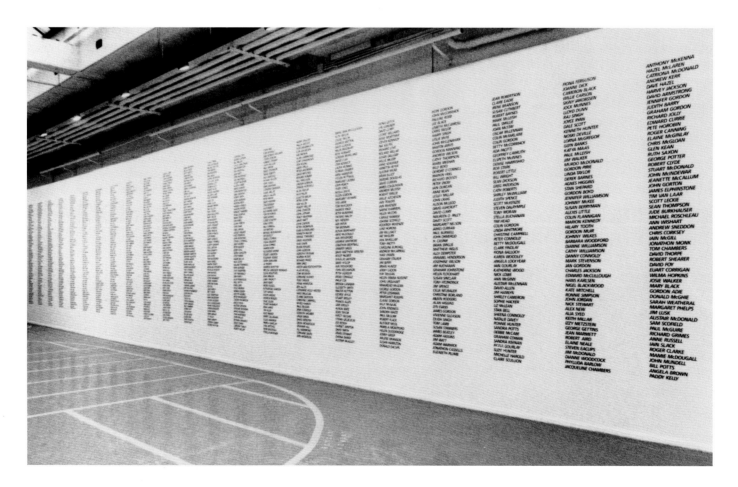

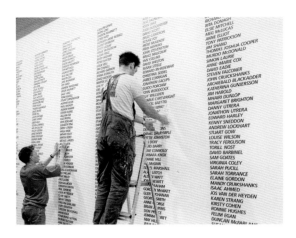

Douglas Gordon installing
List of Names 1990–, Third Eye
Centre, Glasgow 1990 [8]

suggesting the concept of Original Sin, which according to Christian thought is the 'hereditary stain with which we are born on account of our origin or descent from Adam'. Positioned on the ceiling, the work's implication was clearly of a relationship between earth and the heavens or some higher power. Yet the actual source was in fact much more mundane – it was at the time a popular chant among Millwall football fans.

These three works already suggest some of the areas of interest that have sustained his practice to date. In 1990, Gordon began a major work that is ongoing and will continue to be so throughout his life. The exhibition at the end of that year at the Third Eye Centre in Glasgow entitled *Self-conscious State* (with Christine Borland, Roderick Buchanan, Kevin Henderson and Craig Richardson) marked the first time Gordon was to exhibit in his home town since returning from the Slade in London. Increasingly conscious of a desire somehow to acknowledge the relationship between himself as an individual and this public site, Gordon created *List of Names* (fig.7) – a rigorous system worthy of the most ardent Conceptual artist, in which he wrote down the names of everyone he could remember having met in his life up to that point and transcribed them in simple columns onto the gallery wall (fig.8). The list – of 1,440 people – was a kind of living commemoration, monumental in scale and formally recalling a war memorial. It was the first work by Gordon I ever saw and I was in it – we had met in Glasgow for the first time a few months earlier when he was just back from London. Some of the names were familiar to many of the audience, certainly at the exhibition's opening. Others were clearly family. Many people spent the evening searching for their own name, while some would recognise a name and assume it to be the same 'Jack Taylor' that they happened to know. Some were inevitably disappointed.

What sets this work apart from its Conceptual precedent, On Kawara's *I Met* 1968–79, in which every day over a fixed period of time the artist methodically wrote down the names of each person he encountered, is the prominent role played by memory and its threatened fallibility in Gordon's work, as well as its permanent open-endedness. Whenever and wherever it has been installed, its operation on the viewer's memory is complex, and yet the piece is, as Thomas Lawson has said, 'terrifyingly simple': a straightforward strategy that results in an extraordinary anxiety. What if you've met him and you're not there? What if you've never met him and you are? Each time I have encountered *List of Names* since that first showing in Glasgow, I have known I would endure an idiotic but undeniable anxiety that he might have forgotten me, though really I know he won't. *List of Names* relies on the inevitable desire to be recognised, to be identified, to be memorable, to know whether you might be part of this list and what it means if you identify someone you know. It also has connotations of 'the chosen ones', a group whose membership is dictated through no gift of their own, for Gordon has both to have met you and to remember you for you to make it onto the wall.

In a process that Gordon likens to that of the renowned Parisian baker, Poilâne, whereby a handful of dough from the previous batch is added to each new one, achieving continuity through contiguity, the work has subsequently been installed several times, updated from the last showing each time, growing as it goes. It is now a long-term installation at the Scottish National Gallery of Modern Art in Edinburgh, where it currently runs to over 3,300 names and will be updated whenever Gordon shows there. From a simple system grows a monstrous beast, risking collapse every time.

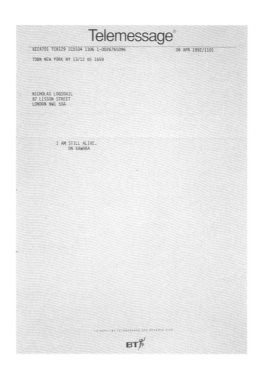

A related work was shown at the Fruitmarket Gallery in Edinburgh in late 1991 in a group exhibition called *Walk On* (possibly another football reference). This involved a casually stacked pile of uniformly-sized timber, resembling a giant game of jackstraws. Each long strip was branded with a small four-digit number, between 1900 and 2000. Among the pile, certain numbers stood out, because they could be understood more readily as dates than serial numbers: 1914, 1967, 1945 and so on, instantly identifiable and meaningful, due to their connection with twentieth-century events or histories, dates of birth and so on. Their incorporation with a pile of other unconnected numbers seemed rather brutal and dismissive, rendered equivalent to meaningless numbers, but also alternatively suggested that whole realms of knowledge and experience might be attributed to the other numbers by different people. Like names, critical dates are key elements of our identity, and of how we are socially differentiated from each other. *1900–2000* (fig.10) highlighted the fragile boundary between recognition and anonymity, positing the unique individual against the undifferentiated mass.

Sharing a use of the serial form, in which no one element is given priority or greater significance than another, *List of Names* and *1900–2000* are among the earliest of Gordon's works to investigate the formation and perception of identity. They expose the function of memory in the shaping of individual identity and how that unique character may be perceived and communicated to others. They also rely on the extent to which even the most personally significant facts can become meaningless, anonymous, suggesting a terrifying potential breakdown.

Gordon's own personal history is explicit in *List of Names*, as is his relationship to the viewer/receiver of the work. 'Receiver' is in many instances a more appropriate term than 'viewer' for the encounter with his work is not a purely visual one, but rather the transmitting of a suggested state of being or thought. The most obvious manifestation of the relationship and the way in which Gordon has infiltrated other people's space is his series of *Letters* (figs.11–12), begun in 1991 (the third of which, reading 'I have discovered the truth', was included in the Fruitmarket exhibition), and a series of *Instructions* (fig.13) rendered as phone calls. Adopting two daily means of communication, Gordon exploits their intimate and personal point of reception. Both series again recall On Kawara (fig.9), whose postcards and telegrams convey simple objective facts about his daily life – their depersonalised tone is in stark contrast with the normal messages conveyed by such means of communication, which tend to be more sentimental. What Kawara does is to acknowledge the very non-private nature of both, which are by necessity exposed to the eyes of others before they reach their intended recipient. Gordon's messages and means are in comparison quite private and decidedly subjective in content. The very first of these letters, which reads 'I am aware of who you are and what you have done', was sent to the other participants in a group exhibition in France. Gordon has said that this work 'was playing on a social situation; lack of knowledge on one side, and a position of knowing something on the other side; even from a peripheral position', acknowledging the remove from the centre of things that living in Glasgow implied at that time.

The information that accompanied *Letter Number 2* when shown in 1991 states that it was sent 'to persons known and unknown', though they tended to be persons somehow associated with the gallery in which the letter would be exhibited. The letters are all dated and signed 'Yours, Douglas Gordon', in a rather

1900–2000 1991 [10]
Wood
101 pieces
Installation view: 'Walk On',
Fruitmarket Gallery,
Edinburgh 1991
Courtesy of the artist

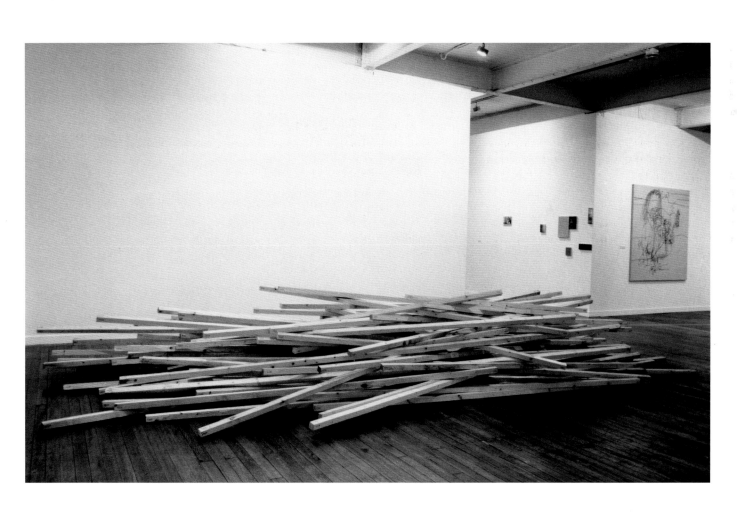

LETTER NUMBER 4 1992 [11]
Print on paper
Collection of the author

London, April 6th, 1992.

Dear Katrina,

If only you were hot, or cold. But you are neither
hot, nor cold. I am going to vomit you out of my mouth.

Yours,

Douglas Gordon.

LETTER NUMBER 14 1994 [12]
Print on paper
Collection of the author

Glasgow, April 25th, 1994

Dear Katrina,

There is something you should know.

Yours,

Douglas Gordon

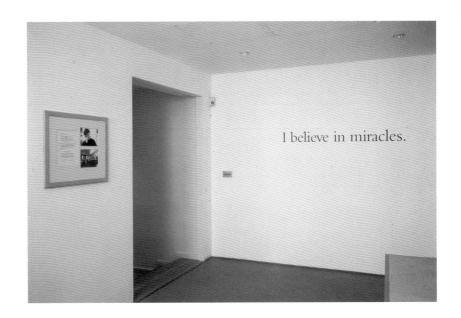

I believe in miracles.

INSTRUCTION NUMBER 7 1994 [13]
Black and white photograph,
document and wall text
Dimensions variable
Installation view: Galerie Nicolai
Wallner, Copenhagen 1997
Collection nVisible Museum
Courtesy Nicolai Wallner, Copenhagen

friendly tone. They contain, however, phrases that can be construed in decidedly unfriendly terms. News such as 'I am aware of what you have done' or 'Nothing can be hidden forever' might be comforting from the right person in the right context and said in the right tone, but arriving in an envelope out of the blue, they become unsettling, threatening, intrusive. Suggesting some kind of coercion, like excerpts from blackmail letters or even love letters, they invoke some kind of emotional extremity or emergent crisis, the point at which reasonable behaviour might slip into the grotesque. They imply unwelcome exposure, an uncomfortable but intimate relationship between sender and recipient, one that involves power or knowledge over the other. This sense of exertion of power over others, the ability to change lives and shape destinies, recurs in several of the films Gordon has worked with, as well as relating to that desire, mentioned previously, to be memorable, significant. The *Letters* also employ the same identification of a select group that is inherent in *List of Names.*

Unlike the *Letters*, the related series of phone calls, the *Instructions* (fig.13), are delivered anonymously. They reach further out into more public, social space. Gordon specifies the words to be spoken, which are also applied as vinyl text to the walls of the gallery with which he is working. His 'collaborator' telephones a public space, often a bar or a café, and asks the person who answers to call to the phone someone he or she knows by name. That person is then delivered the message: 'It's only just begun', 'Everything is going to be alright', 'You can't hide your love forever'. There is an undeniably romantic strain to many of them, though this tends to be overwhelmed by the disconcerting manner of delivery. How does this one simple sentence change a person's mood? What are they thinking? Many of the messages are lyrics from

popular songs (The Carpenters, Hot Chocolate, Bob Marley) and may simply remind the recipient of the music, and of anything with which that song may be associated in her/his own personal experience. For others, the words may strike a stronger chord with their current state of mind – are they in fact hiding something? As with so many of Gordon's pieces, these works give something, only to then retreat from it – the suggestion of emotional excitement or fulfilment is withdrawn as soon as it is offered – for there is no more information to be had, no way of tracking down the caller. For the gallery visitor, the experience is profoundly voyeuristic – coming across words spoken by one unknown person to another in a distant place.

The *Instructions* also benefit from a subtle film connection. Gordon cites a scene in a famous James Cagney movie of 1938, *Angels with Dirty Faces*, in which a familiar ploy is used by the villains to identify their unsuspecting victim. Cagney's character, who is being pursued by his old gang, is called to the phone, but 'he's wise to the scenario, calls some other guy over in his place, who then gets blown away while Cagney flees'.

Given Gordon's belief that art is simply an excuse for conversation, a basis from which dialogue can be had between people, it is entirely appropriate that these works should unfold in social, non-gallery spaces, places where conversations are being had, and where emotional entanglement is perhaps more likely. He inserts something into that arena, hoping to trigger thoughts and emotions that may otherwise not have developed. His interest in interpersonal relationships is not just that of artist-viewer but a more general concern with how we relate to each other, seeking to access and bring into play those commonly shared memories as the mesh that holds society together.

By 1992, Gordon was known primarily as an artist

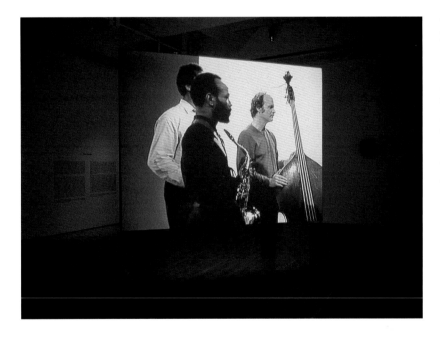

who worked with text. His *Letters* and *Instructions* had, unsurprisingly, attracted considerable attention, since many of them were sent to other artists, critics, curators and those in some way connected to or associated with the exhibition sites from which they were initiated. But the perception of his practice was about to change. Invited to make an exhibition at Tramway, a vast former tram depot on the south-side of Glasgow that has become one of the city's main venues for contemporary art, Gordon produced a work that was to take him into new territory. Having previously resisted video, taken up by so many of his peers as it became more cheaply and readily available, he created a large-scale video projection, *24 Hour Psycho* 1993 (fig.1), which slowed down Alfred Hitchcock's classic film of 1960 so that it would last a full day rather than the original 109 minutes. Instead of the standard 24-frames-per-second speed at which a film is projected, Gordon's projection is viewed at almost 2 frames per second, so that the movement between each is just evident. It is screened without sound, creating an eerily still atmosphere in the midst of this well-known dramatic film. The effect is extraordinary, achieved through an awareness of the established convention, in both television and cinema, that slow motion tends to indicate extreme gravity and significance. Writer Harald Fricke has most astutely described the experience of *24 Hour Psycho*: 'Every shot seemed to last longer than all the paintings you've seen in your life.'

The revisitation of the past that *24 Hour Psycho* invites is in part an acknowledgement of the way in which Hitchcock's film is embedded in and resonates throughout our present, just as Stan Douglas's *Hors-champs* (fig.14), shown at Documenta IX in 1992, revisited the Paris of 1968. Both works use video projection on a two-sided screen, exploiting the

physicality of the screen, breaking down the authority of the single, distant, projected image and invoking the subjectivity of the viewer. *Hors-champs* presents two sequences of film of the same free-jazz performance on either side of a suspended screen, offering two simultaneously present perspectives between which the viewer has to choose. While sharing an apparently similar form, Gordon's approach to his material in *24 Hour Psycho* is by far the more straightforward. It is the starkest example of his incorporation of existent material, by which its co-option and slight alteration can dramatically alter our experience of both the original and the space in which its citation is encountered. The combination of simplicity of form and slowness opens up a kind of clearing in which the viewer can operate: to reflect and contemplate, allowing image and its history to resonate. Demonstrating just how one small change can radically alter perception, how fragile is the basis of our habitual understanding, *24 Hour Psycho* (figs.1, 16 and 18) exploits our memory of the film and the myths that surround it as much as the film itself.

Just as *24 Hour Psycho* draws on a kind of off-beat yet mainstream culture, another video work of the same period derived its content from what has become a cult television series. *Predictable Incidents in Unfamiliar Surroundings* (1992/95) (fig.15) takes a number of excerpts from 'Star Trek', each of which features Captain Kirk in an embrace with a different woman, exposing an unexpectedly passionate strain in the famous sci-fi serial. Gordon's slowed-down footage presents various physical tangles, from the tender to the brutal, which suggest, as does the title, the irrepressible persistence of physical desire as an animating force, no matter what the environs.

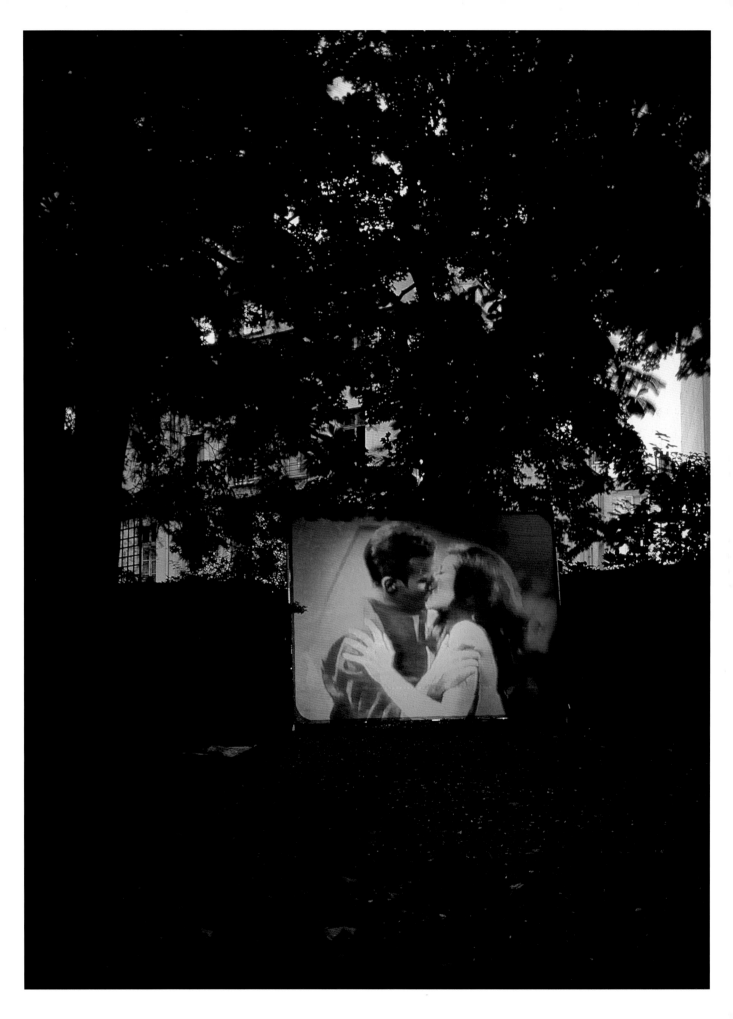

'Is there anyone in the world who doesn't know that in *Psycho* a girl is stabbed in the shower?' Stuart Morgan

24 HOUR PSYCHO 1993 [16]
Video installation
Dimensions variable
Collection Kunstmuseum Wolfsburg;
Bernhard and Marie Starkmann, London

Despite the tendency for this work to be considered in terms of its relationship to film theory and the cinematic, Gordon himself has often described it more aptly as existing 'somewhere between the academy and the bedroom'. Its academic credentials lie in its structural analysis of film in general: stripping it of sound, reducing it purely to the visual, slowing the progression of images to such an extent as to expose each single frame and the transition from one to the next, Gordon leaves us with the basics of image and movement. But its origins in the bedroom are perhaps the more significant, for it grew as much out of the proliferation of domestic video recorders in the 1980s as from any structural analysis. The readily available technology allowed many people both to watch and manipulate films in the comfort and familiarity of their own homes. Comedy was to be found in the use of the fast-forward function, while many a teenage erotic fantasy could be triggered by the use of slow motion. Recalling how the idea for the piece first came about, Gordon has said:

I was back home, it was Christmas Eve, the pubs were closed, my friends weren't around, I'm not used to going to bed very early. There was nothing on the television, my family were all asleep. I remember lying upstairs in my wee brother's bedroom, just playing about with the video recorder, and whatever tapes that he happened to have ... he had a tape lying about and it was Psycho *and when I saw it I thought 'Wow, Five Minute Psycho, that would be really brilliant!' So I tried to watch* Psycho *really fast and it was fair enough, and then I started just doing the opposite, like you do. So I started watching it slow and there were specific sequences in it that I thought I wanted to watch again in slow motion and that's really the root of where the idea came from: the more I watched in slow motion, the more I realised how interesting this could be.*

An understanding of the distinction between both the manner of watching and the type of film watched in the home as opposed to the cinema is a key starting point for much of Gordon's work with video. In a conversation with the late David Sylvester he explains:

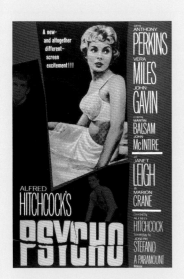

Original poster for Alfred Hitchcock's film
Pyscho, 1960 [17]

I think that ways of looking are determined more by the circumstances in which a film is seen than the commercial or 'alternative' intent of the director. I try not to be too nostalgic about it but, to be quite honest, most of the movies that I've watched, I've watched in bed rather than in the cinema . . . It was not exactly the social context but the physical context of watching that knitted together all of my experiences . . . The cinema was much more of a controlled environment, whereas at home there were always some wise-cracks from your mum or dad, or someone on the telephone, or someone ad-libbing the next line or whatever. This happened more with film noir and B-movies than anything else. Our house was much more Sydney Greenstreet, John Wayne and Barbara Stanwyck than Jean-Paul Belmondo and Jeanne Moreau. Or Steven Spielberg for that matter.

The multi-layered physical experience of and bodily involvement in watching is clearly as important for Gordon's work with video as it is for his text-based works. The ability to encounter an extra-ordinary narrative and unknown characters and places in a familiar, ordinary environment while simultaneously hearing and seeing one's own immediate reality outside the film is the crux of the specifically domestic experience of film that lies behind *24 Hour Psycho*. It conjures a recollection of the all too real fear and foreboding experienced by anyone choosing to watch a late-night thriller on TV, even in the comfort and safety of the home, essentially playing on the way in which the fictional can seep into our memory and intertwine with real, actual and personal experiences.

I used to work on a late shift in a supermarket, and when I came back home the clock was already at midnight or 1 a.m., and everyone in the house was asleep, but I needed to rest and calm down before going to bed. This was around the time in Britain when Channel 4 had just started. It was a very, very important thing: Channel 4 was the only thing on TV at that time of night. They ran a pretty esoteric film series, from what I can remember. And that's how I got to see Godard; that's how I got to see Truffaut, Rohmer, and everyone else. As well as the Vague boys, I also got an introduction to B-movies, and noirs – Nicholas Ray or Rudolph Maté or Otto Preminger, for example.

Such films were to be the starting points for later works, such as *Confessions of a Justified Sinner* 1996 which uses an excerpt from Rouben Mamoulian's 1932

24 HOUR PSYCHO 1993 [18]
Video installation
Dimensions variable
Collection Kunstmuseum Wolfsburg;
Bernhard and Marie Starkmann, London

overleaf: detail of fig.1 (p.6)

version of *Dr Jekyll and Mr Hyde*, and *Déjà-vu* 2000, which features a Maté classic
noir from 1950. *Psycho* is, however, a better known if not necessarily altogether
'popular' film. It is seen mostly on TV, whether as a late-night screening or on
video. Made cheaply and in forty-one days, *Psycho* has attained classic status,
described as 'one of the key works of our age' by Robin Wood, doyen of Hitchcock
critics. Introducing some of the key themes to be found in Gordon's later works,
such as right and wrong (the film starts with the 'heroine' Marion Crane stealing
money from the bank in which she works), madness and the split personality, it
also plays deliberately and directly to a taste for horror. From the outset there is a
heightened voyeurism, explicit in the opening scene when we find Marion in bed
in a hotel room with her lover. From this point on, the viewer is implicated in the
events that follow, choosing to watch. The film, as Hitchcock himself said in
conversation with François Truffaut, 'allows the audience to become a Peeping
Tom'. Gordon's slowed-down version exploits this voyeuristic tendency and
overlays it with a physical involvement that only strengthens the way in which
the viewer is implicated in what unfolds. Since the viewer is able to walk around
the screen, see the projection from both sides and become aware of the
manipulation to which the material has been subjected, the images are more
approachable than they appear in the cinema. They are therefore closer to one's
experience of and physical involvement with them via the domestic video
recorder, while existing on a scale that surrounds and dominates the viewer, who
is effectively suspended in a relentless present.

*I was concerned above all with the role of memory. While the viewer remembers the
original film, he is drawn into the past, but on the other hand also into the future, for
he becomes aware that the story, which he already knows, never appears fast enough.
In between, there exists a slowly changing present.*

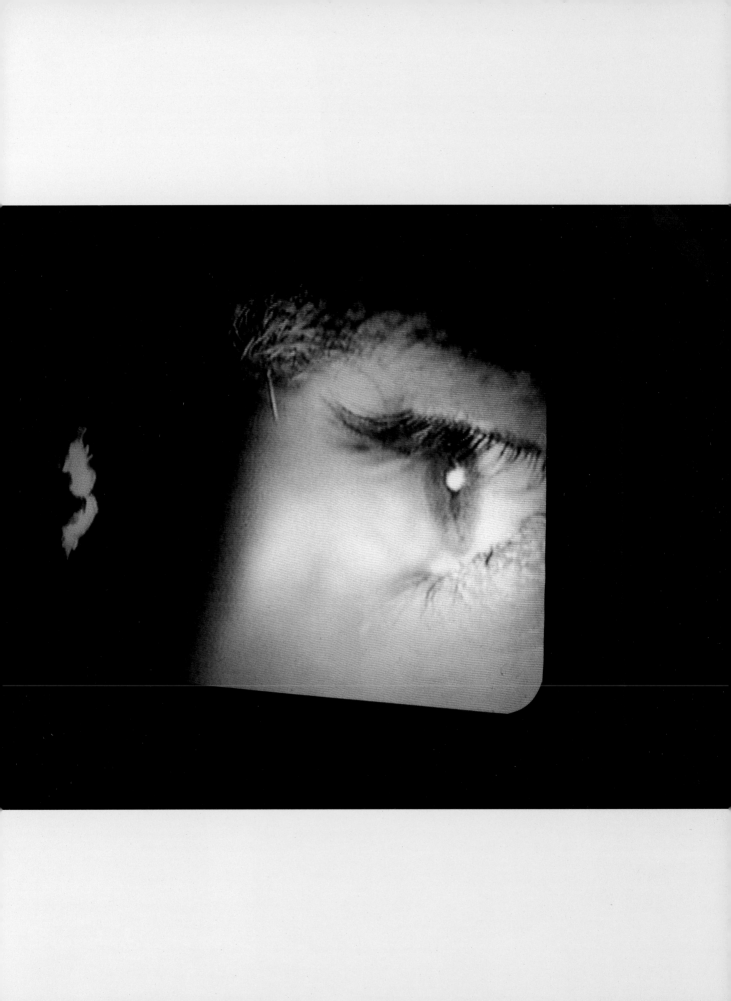

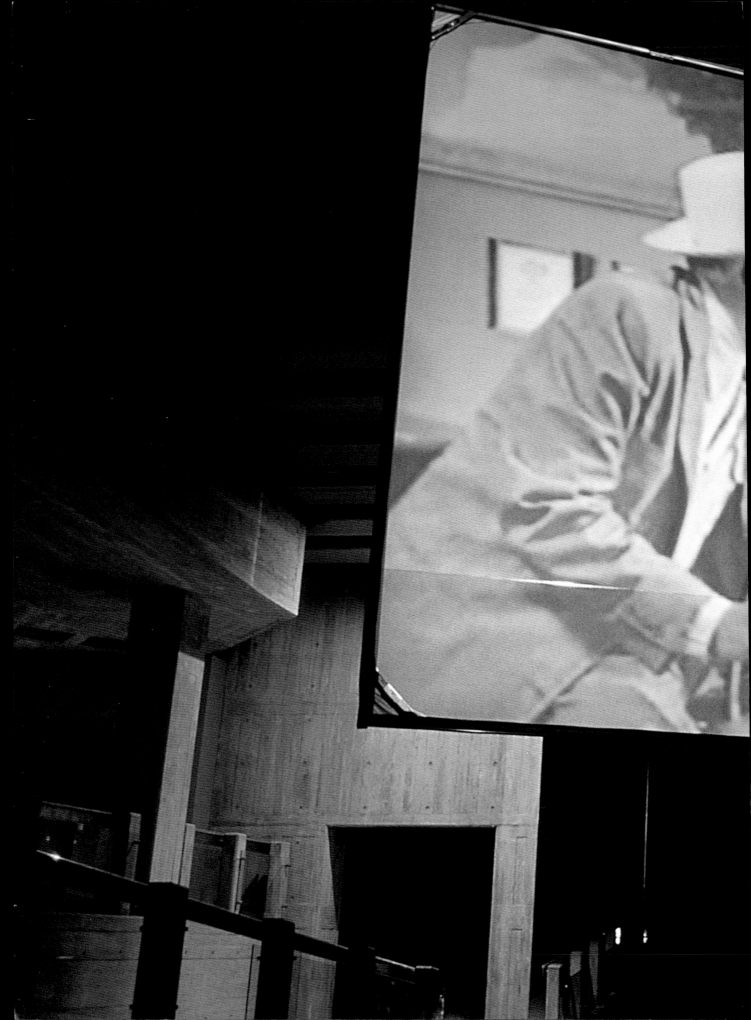

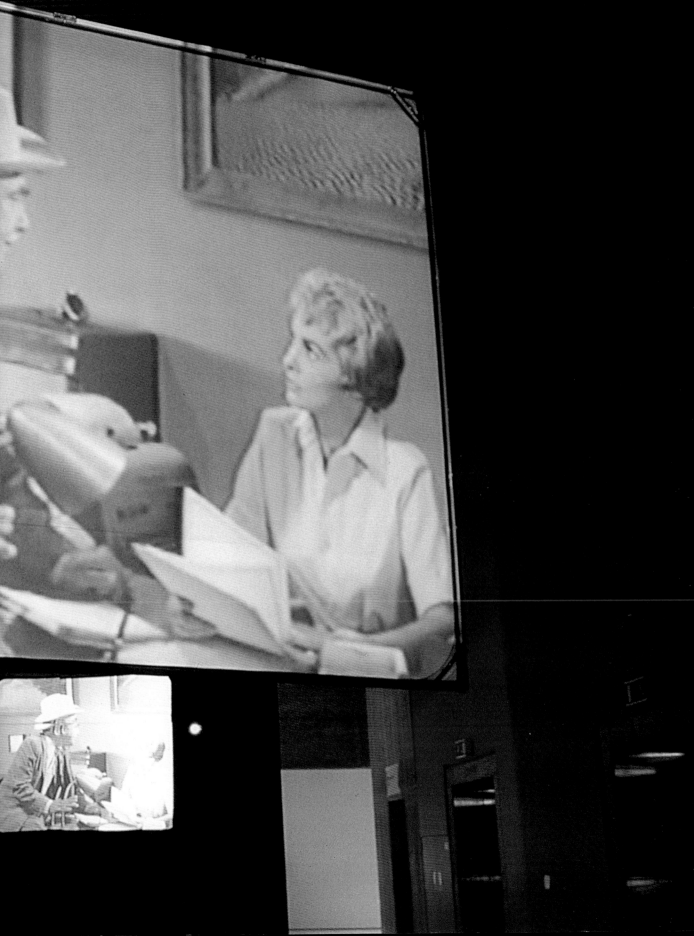

I REMEMBER NOTHING 1994 [19]
Wall text
Dimensions variable
Installation view: 'WATT', Witte de
With & Kunsthal, Rotterdam 1994
Centro Cultural de Belém, Lisbon

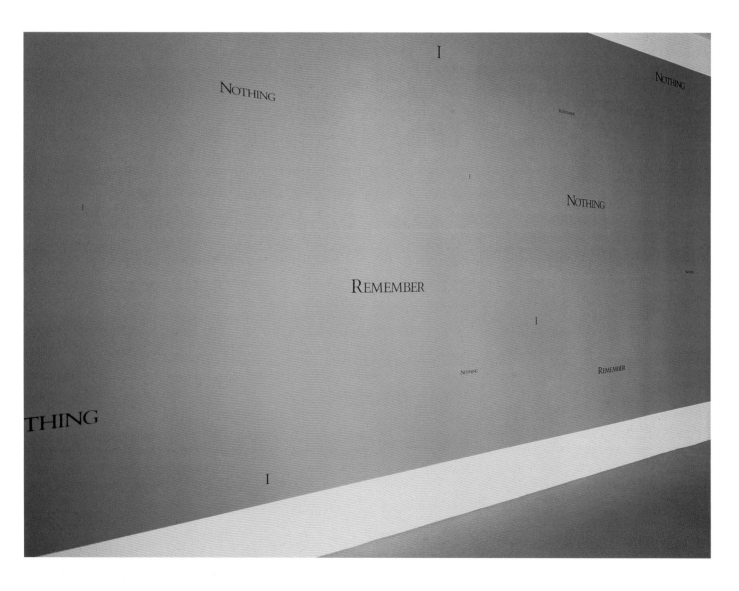

John Baldessari
BALDESSARI SINGS LEWITT 1972 [20]
Video still
Collection of Jack and Nell Wendler
Courtesy of the artist and Lisson
Gallery, London

REMEMBERING AND FORGETTING

2

The continuing series of *Letters* and *Instructions*, along with the video works *Predictable Incidents in Unfamiliar Surroundings* and *24 Hour Psycho*, are indicative of the ways in which Gordon has consistently explored the extra-ordinary through existing common material. They typify Gordon's emergent and now characteristic melding of conceptual and analytic strategies with an astute control of their physical reception, an interest in the psychological, and the co-option of material found in mass culture. His fusion of form and content is almost the perfect inverse of a little-known piece by John Baldessari, which 'softens' the sometimes hard, cold edges of rigorous Conceptual practice through shifting the presentation of a seminal text from print to pop. In *Baldessari Sings LeWitt* 1972 (fig.20) he sang Sol LeWitt's *Sentences on Conceptual Art* (published in 1969) to the tunes of a number of different, mostly rather sentimental, popular songs, including *The Star-Spangled Banner*, hoping to make them more palatable. The tunes are only just recognisable in Baldessari's faltering versions, while the sentences – 'Perception is subjective', 'It is difficult to bungle a good idea' – remain comprehensible. The ironic combination of theory, common culture and emotional suggestion makes for irresistibly comic effect.

Gordon himself has been known to sing, though the only time he has done so in his work to date is in the video *Douglas Gordon Sings 'The Best of Lou Reed & the Velvet Underground' (for Bas Jan Ader)* 1994 (fig.22), an appropriately layered title for a typically layered work. We see him lying on the floor with his eyes closed, headphones on, audibly singing along to music we cannot hear. He is the picture of someone lost in music, moving his head from side to side, singing 'I'll Be Your Mirror' and so on. Stripped of the music and of Nico's coolly detached voice, the

distorted psyche behind the lyrics stands out – 'when you think that night has seen your mind, that inside you're twisted and unkind'. So many of these songs are widely familiar, that it is difficult not to come away from this work humming the song you have come across, pulling it up from your memory of the original.

Essentially frustrating and a little troubling – we cannot hear the music, cannot gauge Gordon's state of mind – the piece seems to be concerned with a relationship between inner and outer being, drawing on the viewer's desire to penetrate the façade, to really see and therefore understand the individual. While the title suggests a connection not just with Baldessari's work but with the many album titles that use the 'X Sings Y' format, the reference to Ader is more cryptic. But the connection with one particular piece by Ader is significant. *In Search of the Miraculous (One Night in Los Angeles)* 1973 (fig.21) is a group of eighteen black and white photographs combined with lyrics from The Coasters' hit *Searchin'*. The images show Ader walking alone through the streets of LA by day and night, apparently searching for something or someone. The words 'Gonna find her', 'If I have to swim a river, you know I will' and 'you know I'll bring her in someday' are handwritten across them. The explicit repetition that seems normal, even necessary, in a song becomes, in this context, worryingly insistent, to the point of being obsessive. Like Gordon's *Letters*, Ader's work takes a light and easy pop song and makes it dark, bringing it to the edges of emotional breakdown, to the point where it slips into the abnormal.

Gordon is compelled by the way in which we submit to music like this, and to films and literature. What intrigues him is the fact that as a result 'virtual' memories of people, places, even emotions that we have never experienced directly, are absorbed into our

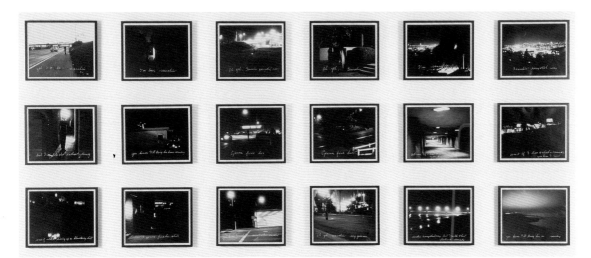

Bas Jan Ader
IN SEARCH OF THE MIRACULOUS
(ONE NIGHT IN LOS ANGELES)
1973 [21]
18 black and white photographs,
written on in white ink
Each 20.3 x 25.2 (8 x 10)
Courtesy Patrick Painter Editions
Inc./Estate of Bas Jan Ader

own personal histories. He sees in those cultural products conduits for the expression and discussion of our identities: 'certain films and some music ... are the means by which we identify ourselves; as individuals and as a community'. Who has not experienced some form of shared reminiscence with friends triggered by a particular piece of music? It can instantly recall specific moments and places in one's own lived experience, brought to mind involuntarily and as a complex inter-meshing of people, place, time, atmosphere and so on. Recalling the familiar inevitably brings other related memories with it – Gordon often talks about how, when you remember a film, you often also recall with whom you watched it or where, details that are beyond the concerns of the film itself but are indivisible in memory from your experience. And it is this varied, personal experience that Gordon seeks out, playing with our subjective and often inaccurate recollections to offer an awareness of the grey areas between right and wrong.

Continuing his use of text and its relationship to the limits of memory is a series of installations using the phrases *I cannot remember anything, I have forgotten everything* and *I remember nothing* (fig.19) (all 1994), each a different articulation of amnesia. The phrases comprise of just three elements, the very basic components of a sentence: subject, verb and object. In each work, the phrase appears physically disjointed, the individual words are scattered randomly and in different sizes across a pale blue painted wall. Each element when read instantly implies another – the subject a verb, the verb an object – typically foregrounding an inter-dependent relationship. Despite their separation, the words insist on coming together through the act of reading, on accumulating meaning. The elements remain connected mentally if not physically, pointing to the irresistible quest for

logic, construction and therefore sense in words. As Gordon says, 'one's knowledge of how to read is inescapable'. What the specific phrases also highlight is that between the self and nothing/every-thing/anything, lies only memory. As Luis Buñuel wrote in his memoirs: 'memory is what makes our lives. Life without memory is no life at all. Our memory is our coherence, our reason, our feeling, even our action. Without it we are nothing.'

Gordon's own memory was again the focus of examination when he was invited to participate in a project called *The Reading Room* in 1994. The pro-posed theme led him to think about the activity of reading as effectively an internal action in which material is absorbed, where something external penetrates the internal space of the 'reader' to become part of her or his being. Gordon's approach to the project demonstrates his increasing interest in and exploration of both the function and fragility of memory. It also exemplifies a pseudo-scientific approach that appears in several works, similar to that of an amateur anthropologist or archaeologist, using historical analysis, but only up to a point. His focus was that marginal period of human existence immediately prior to birth, when an individual has not yet assumed his or her autonomous physical form, is not yet an independent being, but is somehow and undoubtedly present. *Something between my mouth and your ear* 1994 (fig.23) comprises a room painted and carpeted in blue and lit only by diffused natural daylight, in which a cassette player and speakers lie on the floor, a characteristically rigorously controlled yet simple space. The music that emanates from the speakers is a selection of thirty songs first released during the period January to September 1966 – the months during which Gordon's mother carried him in her womb. It ostensibly allows us to hear something of

DOUGLAS GORDON SINGS 'THE BEST
OF LOU REED AND THE VELVET
UNDERGROUND' (FOR BAS JAN
ADER) 1994 [22]
Video still
Collection FRAC Rhône-Alpes
Courtesy of the artist

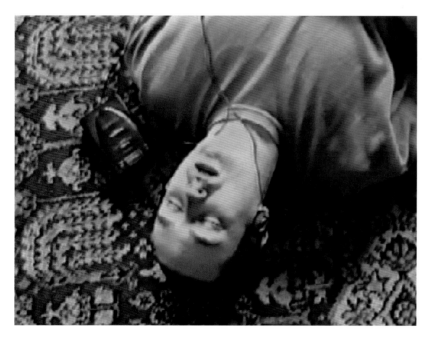

the formative material to which he may have been exposed before birth. Writing about the development of the work, Gordon describes how the list of songs came about:

I try to think of the first sounds that I might have come across and where I might have heard them. I discuss this with some friends in Glasgow and we end up talking about the time immediately prior to my birth; these would be the months in which I would first encounter any received information. I begin to dig up as much material as I can on events between January and September 1966. I visit the Mitchell Library in Glasgow and spend some time in the Music and Arts Reading Room where I discover they keep back-issues of Melody Maker, *a music paper from the specific time I'm interested in. This is perfect. I begin to compile lists of songs from the 'Pop 50' as it was called in '66.*

So far, so straightforward, though the application of a logical, objective approach to such a personal, subjective matter serves to emphasise the disparity between the two. Gordon could of course simply have asked his mother what sort of music she may have been listening to. This might have been the route of someone adhering to a strictly Conceptual approach, in accordance with LeWitt's *Sentence No.29*: 'The process is mechanical and should not be tampered with. It should run its course.' But Gordon's more subjective intent, ultimately denying the historicist approach, is revealed as he continues: *There were some dreadful things in the charts during the time ... I decide I have to be thoroughly subjective, which means goodbye to PJ Proby, Jim Reeves and Tom Jones, among others.*

Those that made the cut include many well-known songs – Simon & Garfunkel's *Homeward Bound*, The Walker Brothers' *The Sun Ain't Gonna Shine Anymore*, the Mamas and Papas' *Monday, Monday* – as well as several whose titles could almost be works by Gordon in their own right: *Paint It Black* (The Rolling Stones),

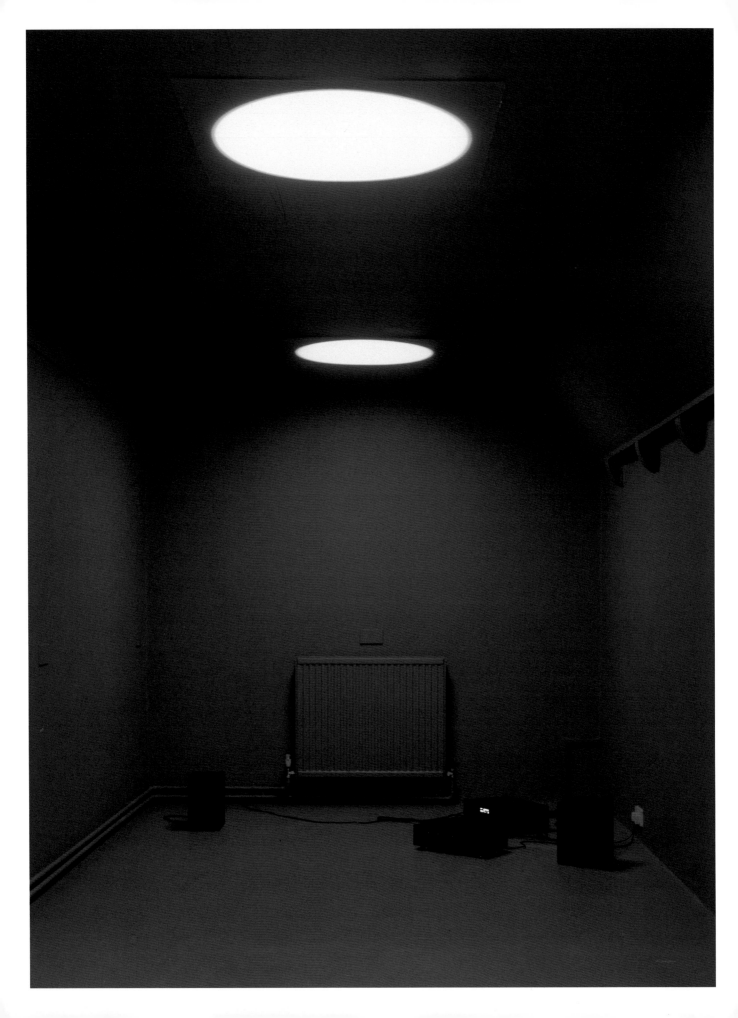

SOMETHING BETWEEN MY MOUTH
AND YOUR EAR 1994 [23]
30 songs (from January to
September 1966), blue paint,
light filters
Dimensions variable
Installation view: *The Reading Room*
(a project by Book Works),
The Dolphin Gallery, Oxford 1994
Collection Bernhard and Marie
Starkmann, London
Courtesy of the artist and Book
Works, London

I'm a Believer (The Monkees), *All or Nothing* (The Small Faces). Whether or not Gordon's mother or anyone around her at the time of her pregnancy might have been listening to any of these is of course unknown and unknowable to us, so the pseudo-scientific approach with which the work began collapses in the final tendency to subjectivity and choice. The room itself feels submerged, the colour and diffused light contributing to an under-water, womb-like atmosphere in which sound is the only stimulus. It is a comfortable space, easy to spend time in. Gordon's very moment of coming into being is the core of the work, and, just as with *List of Names* (fig.7), his identity lies at its heart. It is undeniably autobiographical, if in an uncommon way, yet by restricting this 'portrait' to widely shared and differently associated cultural references, the work tends to heighten the fragility of identity, almost stressing the common over the individual. For what the title suggests to be a unique and deeply personal connection could in fact be true for anyone born in September 1966.

Both works are among a number in which Gordon has made use of his own history and body as the most immediate and readily available material, in many ways similar to traditional self-portraits. However, he probes the relationship between self-portrayed artist and viewer in subtle ways that tend to emphasise the viewer's role in discerning the artist's persona. He plays with our desire to know or understand the artist, giving a little only to conceal more, asking us to choose what we believe, stressing that choice and desire will be brought to bear on the process. Will you believe what you are shown? The last time I saw *List of Names* (in Edinburgh) I overheard a couple next to me discussing what it was. At first they thought it was a list of sponsors or donors, before they realised its

extent. The man read out the text that accompanied the work to clarify what it was in fact – 'a list of all the people he can remember having met'. The woman could not believe that one person had met so many people. He read further, affirming that no, he really had. Her response was: 'So how do we get to meet Douglas Gordon?'

Gordon has consistently been both conscious of and willing to exploit this desire and the charged relationship between object and subject, the essential nature of relationships between one person and another, between individual and crowd, between artist and viewer. These are among the concerns of a group of photographic works, the earliest of which were presented as 35mm slide projections in his first solo show at the Lisson Gallery, London, at the end of 1994. *Kissing with Sodium Pentothal, Kissing with Amobarbital* (fig.24) and *Self-Portrait (Kissing with Scopolamine)* (fig.25) (all 1994) involve the use of supposed 'truth drugs', worn on the artist's lips, truth being a concept of enduring appeal: *I was always into this idea of finding the truth anyway, somehow or other, in everything.* The former two works present a sequence of negative black and white images in which Gordon appears kissing a number of different people, while purportedly wearing the eponymous substance on his lips. All eyes are closed, though these are friendly, familiar greetings rather than passionate embraces. The *Self-Portrait*, however, also a negative, is a single, constant projection, showing Gordon, eyes closed, kissing his own reflection in a mirror, his most specifically narcissistic work. Of this piece he has said: 'The viewer sees a negative of the truth, and a negative of the self, and a negative of the reflection of the self … I love that kind of endlessness. It's an endless image, an endless game.' The image, like *Douglas Gordon Sings 'The Best of …'* is literally impenetrable, refusing

KISSING WITH SODIUM PENTOTHAL
1994 [24, left]
35mm slide projection sequence
Collection Bernhard and Marie
Starkmann, London

KISSING WITH AMOBARBITAL 1994
[24, right]
35mm slide projection sequence
Collection Antoni Estrany, Barcelona
Installation view: Centro Cultural de
Belém, Lisbon

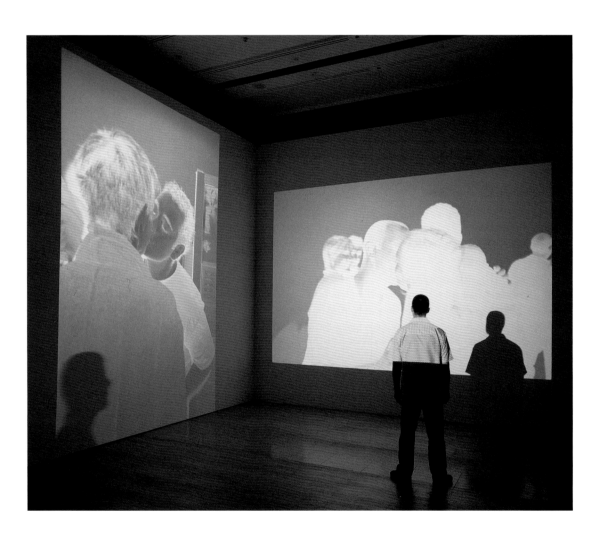

SELF-PORTRAIT (KISSING WITH
SCOPOLAMINE) 1994 [25]
35mm slide projection
Courtesy of the artist and
Nicolai Wallner, Copenhagen

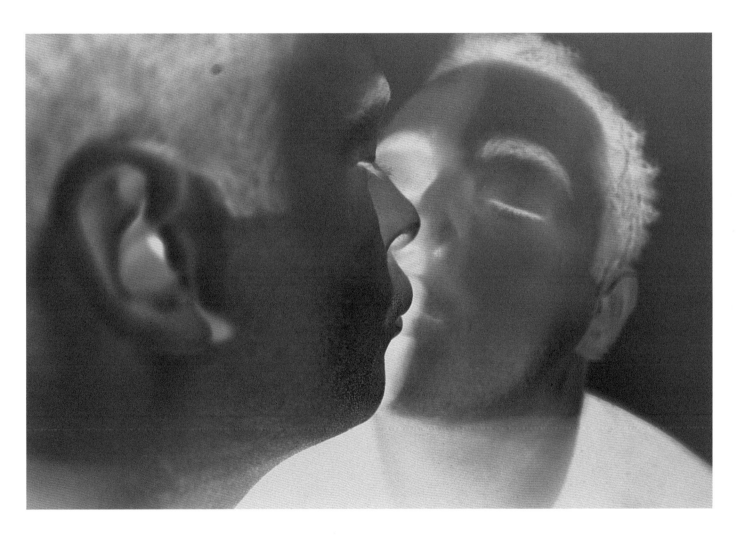

resolution, insisting on an infinite boundlessness that is a common attribute of much of Gordon's work.

The *Kissing* works continue something of the pseudo-scientific in Gordon's practice, not least in their use of photography to compare like with like – how does one recipient compare with the next? What are the distinguishing characteristics? Photography was quickly adopted early on in its technical development for use in psychiatry by French neurologist Jean-Martin Charcot and others, who sought to understand mental disorders. It was widely used to record the ephemeral manifestation of extraordinary states, the passing expressions that were thought to typify the disorders. As early as 1876 Charcot published a photographic record of the patients he had studied, *Iconographie Photographique de la Salpêtrière*, and it made possible Charles Darwin's studies illustrating his *The Expressions of the Emotions in Man and Animals* published in 1873. Such images, however, often betray a fondness for the subjective and aesthetic over the supposedly objective purpose. Dr Hugh Diamond's artfully-posed studies of the mentally ill made in the 1850s are a good example of this. The application of photography in these areas undoubtedly underpins the *Kissing* works' format and the suggested use of mind-altering drugs that also relates to Gordon's developing fascination with extreme mental states, whether wilfully induced or involuntary. Even with the works that have their origins in mundane pop songs or television programmes, the shared feature of an encounter with these excerpts in Gordon's work is an awareness of states such as fear, emotion, anxiety, desire or excitement.

The second work of this period that draws on the relationship between artist and viewer is *Tattoo I* and *II* 1994 (fig.26), two black and white photographs of his arm, on which he had just had the first of several

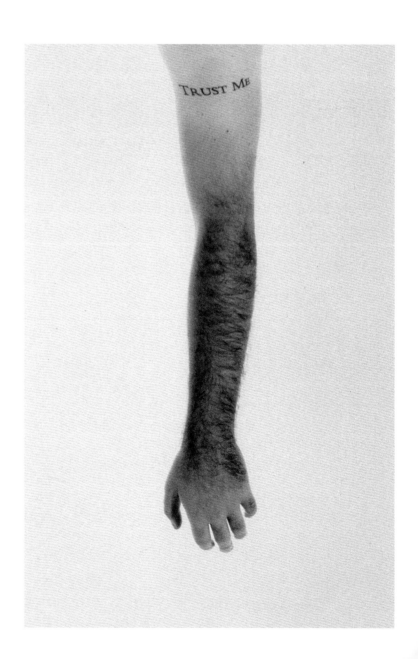

TATTOO (I) and (II) 1994 [26]
Black and white photographs
Each 134.5 x 88 (53 x 34 5/8)
Sadie Coles, London

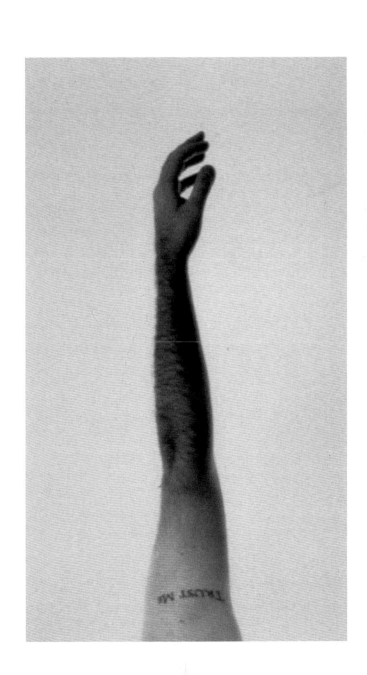

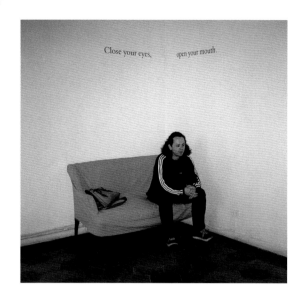

Close your eyes, open your mouth.

A FEW WORDS ON THE NATURE OF
RELATIONSHIPS . . . 1996 [27]
Wall text
Dimensions variable
Fondazione Re Rebaudengo-
Sandretto, Turin

tattoos. The words 'Trust Me' are inscribed on his upper left arm, using his now familiar Bembo type. The arm appears floating on a white ground. Like the later text-based work, *A few words on the nature of relationships . . .* 1996, which reads, 'Close your eyes, open your mouth' (fig.27), *Tattoo I* and *II* invite thoughts of betrayal and forgiveness, of emotional entanglement, themes that run through the texts sent as letters or instructions.

A conversation between Gordon and cultural historian Francis McKee likened the effect of watching *24 Hour Psycho* (fig.1) – simultaneously knowing the past and the future (of the film's narrative) while suspended in an almost motionless present – to a schizophrenic experience. This discussion, as well as the narrative of the original film, in which Norman Bates is 'possessed' by his dead mother, led him to explore the history of altered states, and particularly schizophrenia. In the Wellcome Institute's extensive archives in London, he looked at a remarkable collection of film footage made of subjects suffering from a variety of mental conditions, where some external force has apparently taken control of the patient's body.

The grainy black and white footage he found there features in three works, *Trigger Finger* 1994 (fig.28),

10ms⁻¹ 1994 (fig.29) and *Hysterical* 1995 (fig.30), each of which ostensibly documents the ways in which memory is inscribed on the body. The subjects are victims of psychic rather than physical trauma, conditions that were only beginning to be understood at the turn of the last century, at the same time as photographic technologies were increasingly available to medical study. Much of the footage stems from the influence of the pioneering work of Charcot, whose method of study was primarily visual observation, as opposed to Freud's later privileging of the oral.

Trigger Finger uses footage from around the time of the First World War of a young man's hand. Three fingers are tightly folded into the palm of the left hand, the index extended taut, like a child mimicking holding a pistol. The hand is perfectly still at first, the flickering specks and grains of film the only indication that what we are looking at is in fact a moving image. Then it begins to shake, as if the gun were being fired. The finger then turns to point to the camera-viewer. This disembodied hand has become the embodiment of some past and unknown trauma, a violent and horrific event that now possesses the victim, who cannot escape it. Like an indelible tattoo, the memory of some shocking act in the past is permanently, if internally, inscribed on the body.

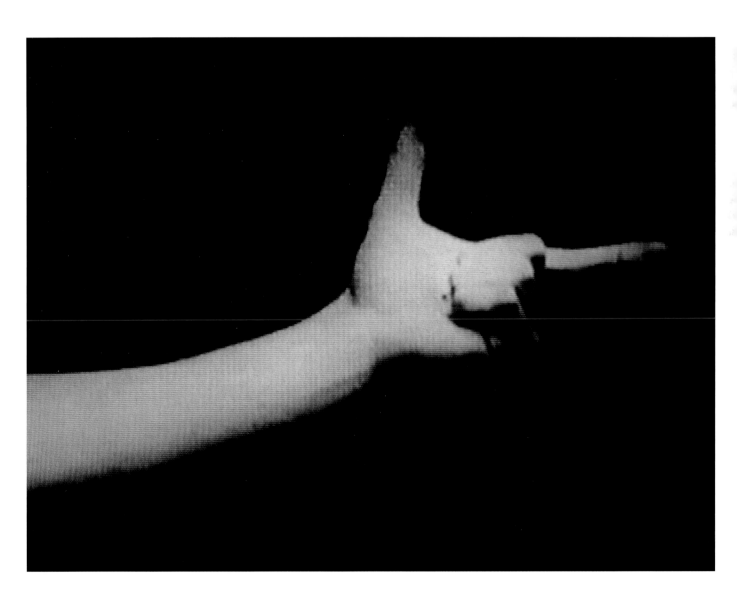

These films were clearly documents of human beings, now dead, under some stress as a result of problems unknown. What do you do with these images as a viewer: stand back and enjoy them or stand back and endure them, or stand back and read them as documents and metaphors all at once and together?

Like *Trigger Finger*, *10ms⁻¹* uses footage that records and observes the body as conduit between past and present, its actions becoming the physical manifestation of mental scars inflicted by some unknown past event. It presents unaltered footage of a young man dressed only in underpants in a room sparsely furnished with a metal bed frame and a screen, just enough information to imply some kind of medical institution, though at first sight the man appears to be in good health. The film records his painful attempts to walk, before falling over, and his subsequent almost unbearable inability, despite repeated attempts, to stand again. Gordon explains how his use of the material developed:

There's very little that can be understood from the film alone; there has to be supplementary information. But the fact is that now these images are floating round the world; they can be picked up on the Internet, like any other images free from supplementary information, which in a strange way is an aestheticisation of some-thing that's quite disturbing. What intrigued me was the tension between this incredible aesthetic and the fact that it had become dislocated from the root of what it's supposed to be about. That I suppose is the key thing in all of the work that I'm doing whether with cinema or text or whatever. It's quite a radical dislocation from its roots but at the same time it's quite slightly done as well.

He describes his approach to found material as '*making the critical cut, but still pro-viding a bit of a link . . . like cracking a bridge in half so it wouldn't function any more but people could still maybe leap from one side to the other.*'

Stripping the films of their makers' instructive intent is at the root of the work. But crucial to its impact is its physical constitution, which stresses the relationship between viewer and subject and therefore the potentially sadistic tendency to which Gordon alludes. The screen onto which the image is projected rests casually on the floor, in the middle of the space, propped against a black pole braced by

ceiling and floor. It is large enough to depict the young man almost life-size. One can walk around the screen, or between the projector and screen, inserting oneself in the image as a shadow/negative presence. The sense of involvement is intense and is multiplied by a moment in which we become acutely aware of the camera. When the man falls, the camera struggles to keep up with him – letting him slip momentarily out of frame. In that instant, our own desire to watch is exposed.

There's a real problem here, about how one is supposed to look at these images. Firstly, we don't know where to locate the image in terms of a context. It could be Hollywood but it could also be real. And the medium is film and video but it's not shown in a cinema, as something to be sat in front of and watched. Perhaps there is a narrative, but perhaps not. How long are viewers prepared to watch something before they can decide what it is they're watching? It's also not an image that has been constructed by the artist, so what are these images doing here and why are we looking at them? And if you do look at the images, then you have to walk around them; you can see that what's happening on screen might be quite painful – both physically and psychologically – but it has a seductive surface. What do you do – switch off or face the possibility that a certain sadistic mechanism may be at work? I think that the confusion caused by reappropriating these images, and collapsing the system they're associated with, can be quite interesting.

Gordon has used such physical proximity to the screen in several of his works, describing the strategy as follows:

You have the opportunity to do something you're never allowed to do in the movie theatre – touching the screen. In the theatre usually you keep a distance. And the metaphor of distance is the metaphor of voyeurism. But when you get closer and closer you can actually take the sadist's part, if you're close enough to get involved.

In *10ms⁻¹*, whose title references the exertion of a downward force (10 metres per second), this proximity is at its most intense: the footage is real, not fictional, and quite obviously so. The subject needs assistance that we are unable to give; he is destined to repeat endlessly something painful and distressing, performing before his unwanted audience.

One of the details that engaged me most with these works was how people were able to pick up on the distress of the films – both physically and metaphorically. This was the point at which I started to talk less about voyeurism and more about sadism – because these films were so extreme in some ways.

It is surely the case that every human being is interested in neuro-psychological phenomena because, statistically, every family has had, or will have, some experience of dysfunctional behaviour. So it's something we live with. We can be fascinated by this subject and we can be terrified of it. So for me, fear and repulsion and fascination are critical elements in both the world of science and the world of cinema. We can be attracted to the spectacle of cinema while watching something completely repulsive.

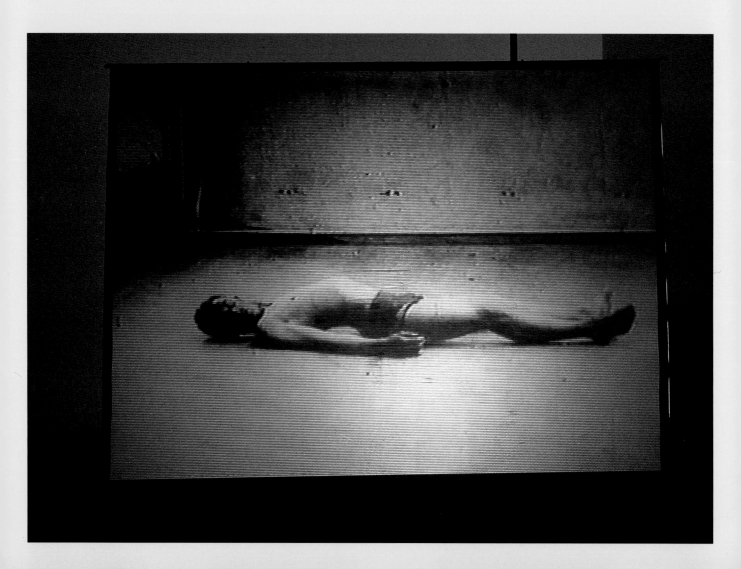

10MS⁻¹ 1994 [29]
Video installation
Screen: 228.5 x 306 (89 ⁷⁄₈ x 210 ¹⁄₂)
Stedelijk Van Abbemuseum,
Eindhoven; The British Council;
Tate, London

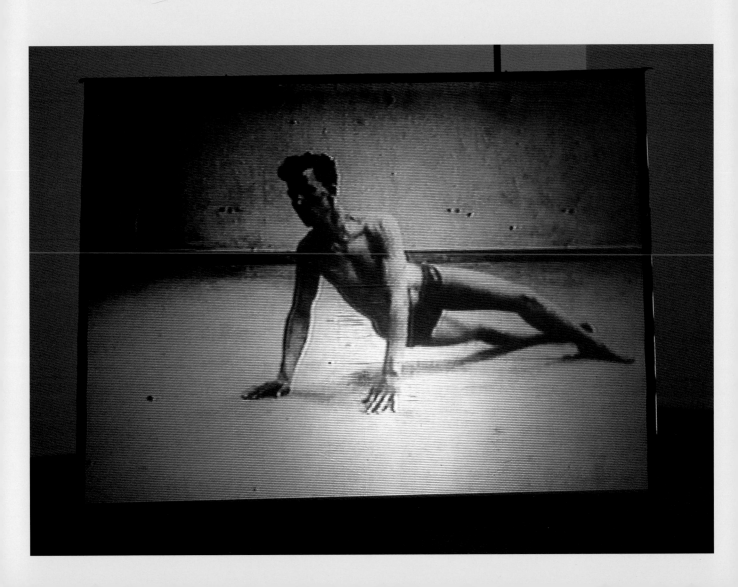

HYSTERICAL 1995 [30]
Video installation
Dimensions variable
Collection of Contemporary Art
Society, London (Gift the
Southampton City Art Gallery);
Musée Départemental de
Rochechouart

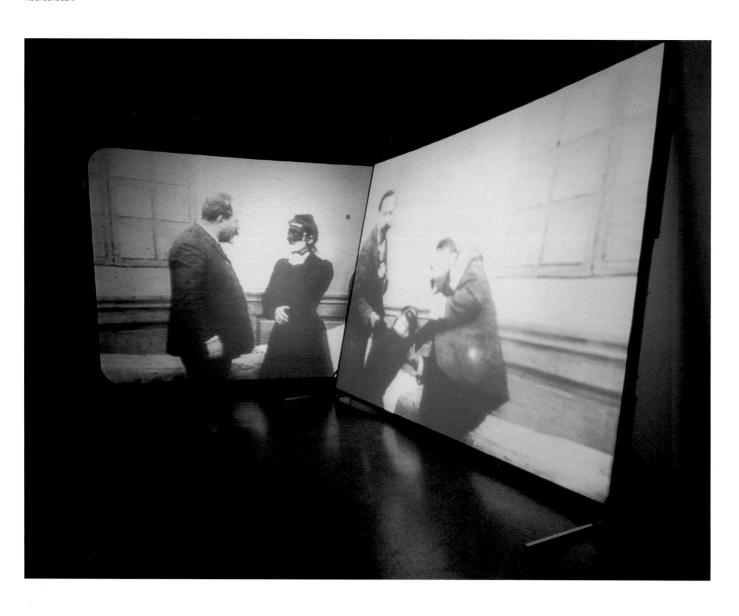

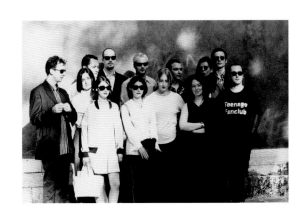

3

BAD BEHAVIOUR

The stark formal simplicity of *Trigger Finger* and *10ms⁻¹*, in which unedited, untreated material is extracted from its source and transferred from film to video for ease of playback and projection on a single-screen, accommodates a fundamental duality of content: the disparity between the apparently healthy outer being, with no physical scars or wounds, and the damaged, dysfunctional inner being that is subsequently evoked. Such paradoxes are a key feature of Gordon's work, more explicitly present in the third piece to emerge from his archive research, which heightens the tensions present through a more complex treatment of the chosen material.

The physical splitting and mirroring techniques that have since become a recurrent factor in many of Gordon's major works first appeared in *Hysterical* 1995 (fig.30), a two-screen video installation, made for the exhibition *General Release: Young British Artists* in Venice during the 1995 Biennale (fig.31). The two large screens are again propped almost casually on the floor at a slight slant and an obtuse angle to one another. Both relay the same footage, one playing in real time and the other in slow motion. One sequence is inverted, so that when the footage very occasionally and briefly coincides, a symmetrical double-image appears. The footage itself dates from 1908 and shows a young woman who appears to be undergoing some kind of fit or seizure, which is 'treated' by two attendant male doctors. The characters appear in a simple, stage-like room whose only visible details are an iron bed and a window frame. Watching the real-time projection, one is irresistibly reminded of early silent films: the exaggerated expressions, the damsel in distress rescued by gallant heroes, the stilted movements and, of course, the silence. But the parallel slowed-down version brings forth something more sinister. It allows moments of self-consciousness to be perceived, revealing that the incident is in fact staged rather than spontaneous. Unlike in the other works, this 'loss of control' seems to have been enacted for the camera, rather than being a true recording of something real. Other factors contribute to this: the female 'patient' wears a black eye mask, to conceal her identity; the 'doctors' tend to look to the camera more often than one would expect of real doctors attending to a truly distressed patient. The seizure also conveniently takes place right in front of the bed, which is exactly centred in the frame throughout the film. When the fit strikes, the men subdue the woman with some force and restrain her on the bed, where they apply pressure to her groin, apparently 'curing' her.

Watching this piece gives rise to a growing unease, generated in part by the apparent cruelty and even enjoyment that comes through in the slower version of the footage, in part by the knowing glances of the doctors, which seem directed at the spectator, who is therefore made inevitably complicit in the manipulation of the woman. But it is also due to the work's physical configuration. As with *10ms⁻¹* (fig.29), being in the space of the projection places the viewer in the arena of the depicted events, connected by scale and position, though the gap in time remains unbridgeable. The viewer can intervene in the image – by blocking it – but not in the events. The complexity of *Hysterical* lies in the fact that of the two images, one is projected from the front and one from the rear, with the film equally visible on both sides, making for a heightened disorientation as the viewer tries to find a way of being in the space with the work that does not impede the projection.

In addition to the actors' clear awareness of the camera, the viewer's position between projector and projected is a key part of the work, as is the dual time frame, offering two simultaneous moments. The

FILMS NOIRS 1995 [32]
Video installation
Installation view: Stedelijk Van
Abbemuseum, Eindhoven 1995
Courtesy of the artist and Stedelijk
Van Abbemuseum, Eindhoven

relationship between the two different time frames – which constitute past, present or future – is unclear, revisiting something of the split consciousness engendered by *24 Hour Psycho* (fig.1), with which it also shares the use of slow motion to imply the revelation of some previously undisclosed truth. Other works, including *Something between my mouth and your ear* 1994 (fig.23), have similarly suggested this pseudo-scientific quest to discover latent truths. What at first appears melodramatic, even humorous in real time, becomes more sinister and uncomfortable when examined in closer, slower detail, a duality furthered by the work's title, which carries both colloquial and specific medical meanings. In *Hysterical* Gordon confronts the viewer with this co-existence of the comic and the cruel, a pairing that is the basis of so much mainstream entertainment, reminding us as he says that 'we can be attracted to the spectacle of cinema while watching something completely repulsive'.

Witnessing crises endured by others from the comfort of a known, safe environment is a mainstay of popular culture, from the comedy sketch to the thriller. This acknowledged public taste for horror, the idea of fear as entertainment, was something that Hitchcock undeniably played to and has been a pre-occupation of Gordon's, particularly evident in those works that feature psychiatric patient studies. Our undoubted if unpleasant readiness to be compelled by that which we find unsettling underscores much of Gordon's work, but, unlike those pieces that use commercial feature films, *Hysterical* and the related works do not bring into play any previous knowledge of the film, the story, the actor. Recognition is not a factor here. With these works, what we are dealing with is the physical effect of the subjects' suffering rather than our own memories. What the psychiatric

study material allows is a representation of extreme states experienced by anonymous figures and consequently an exploration of our responses to their actual rather than fictional existence. The identities of the individuals who appear in these works are impenetrable; they can only be surmised from the scant information contained in the films themselves. Whatever disorders are present, we see the individuals who endure them only as objects of study. They are effectively dehumanised.

Aware of the undeniable aesthetic appeal of the archive material and its ability to confront the problem of complicity, Gordon continued to explore this particular vein for an exhibition at the Stedelijk Van Abbemuseum in Eindhoven in 1995. He began by visiting another archive of similar material in Utrecht. A number of films found there form the basis for a group of works sharing the title *Film Noir* (all 1995). The footage in this instance dates from the period immediately after the Second World War, documenting the movements of different parts of the body of one man following insulin coma therapy. He was one of the many thousands who suffered psychological damage during the war to be subdued with high doses of insulin and later retrieved from the resultant coma with sugar. Gordon recounts that 'when they come out they are basically rebirthed and exhibit every stage of the new-born child'. The patient chosen by Gordon is anonymous and only ever seen in part – the films focus separately on his hand, his head, his eyes, each presumably intended to be studied as signifiers of his inner mental state. These details are shot so close up that at times they appear like an abstract monochrome composition. It is powerful stuff, that Gordon hoped would be 'potent without being shocking'.

The installation in Eindhoven comprised six pieces

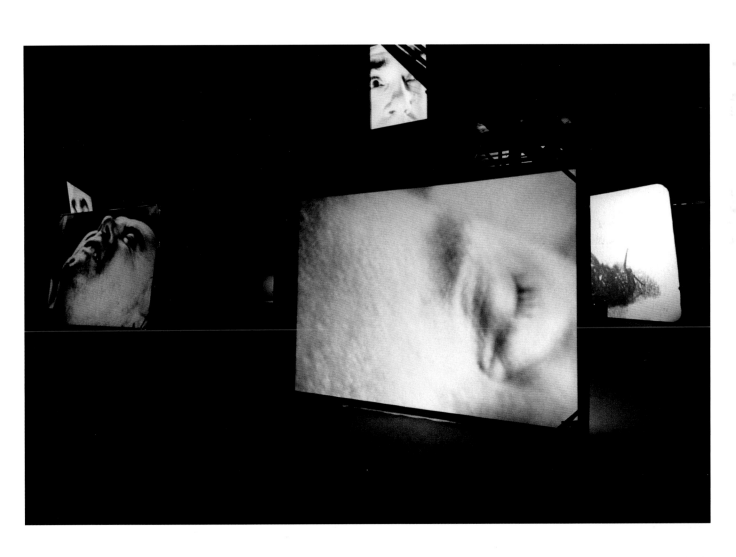

FILM NOIR (TWINS) 1995 [33]
Video installation
Installation view: Stedelijk Van
Abbemuseum, Eindhoven 1995
Courtesy of the artist and Stedelijk
Van Abbemuseum, Eindhoven

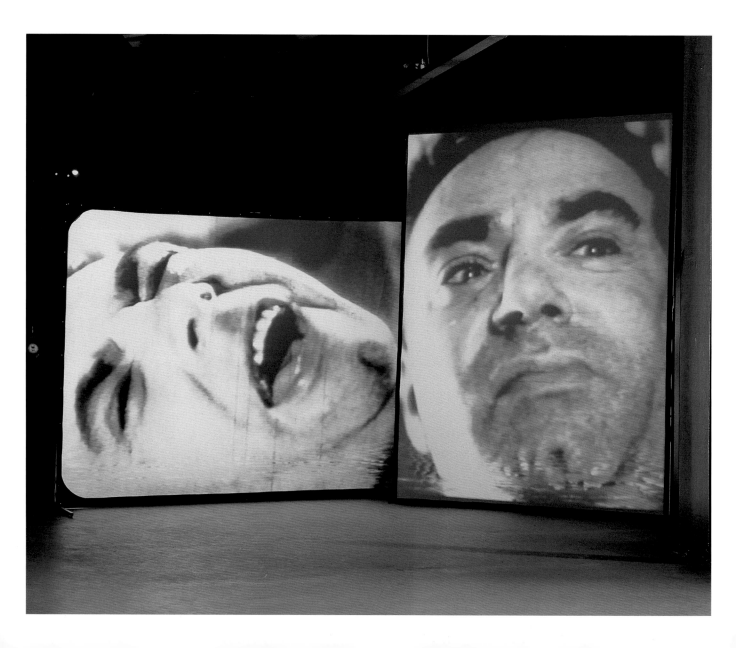

BLACK AND WHITE (BABYLON)
(detail) 1996 [34]
Video installation
Nina and Frank Moore, New York;
Micheline Szwajcer, Belgium

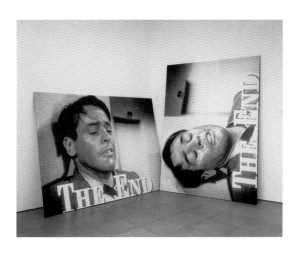

THE END (SPLIT-SECOND
CONFIGURATION) 1995 [35]
Print on canvas; 2 parts
180 x 240 (70 7/8 x 94 1/2)
Stedelijk Van Abbemuseum,
Eindhoven

in total, five using this disturbing footage and one, projected on a screen of the same size as the others, showing a dying fly. The inclusion of *Film Noir (Fly)*, the juxtaposition and implied equivalence of human and insect, gave the installation an extreme tension, both subjects utterly objectified, the man seen only as disembodied parts. Watching the dying twitches of the fly recalls the innocent cruelty of childhood curiosity rather than scientific observation, but a sense of inhumanity is common to both sets of images. *Film Noir (Hand)* seeks signs of inner life in the subject's fingers, while *Film Noir (Perspire)* (see fig.32) focuses on his sweat-covered brow and one closed eye. In the extreme close-up of *Film Noir (Fear)* the patient appears awake and terrified by we know not what. *Film Noir (Twins)* (fig.33) uses two screens, one vertical, the other horizontal to present two sequences of images showing the man's face, as he endures a range of emotions that may be anxiety, fear, confusion. The dual forces of fascination and repulsion come to the fore as the viewer is confronted with the cruelty of this observation without assistance.

Even though Gordon's interest in film appeared to shift with these works to the more restricted, private, institutional world of medical archives, the impact of *24 Hour Psycho* and its reception as cinematic deconstruction had been such that his work was included in a number of important international exhibitions that coincided with the 100th anniversary of cinema in 1996. These sought to explore the ways in which the medium and history of film had penetrated visual art. *Spellbound* at the Hayward Gallery, London included *24 Hour Psycho* (fig.1), while Gordon also participated in *Hall of Mirrors: Art and Film since 1945* at the Museum of Contemporary Art, Los Angeles and *Scream and Scream Again: Film in Art* at the Museum of Modern Art, Oxford. For the latter exhibition, he

made a new work, the first in a series that would utilise illicit, underground material as its source. *Black and White (Babylon)* 1996 (fig.34) uses a 'stag movie' of a female stripper, made illegally on 16mm film during the 1950s for screening in gentlemen's clubs or as home entertainment. In Gordon's work, the same footage is projected in slow motion on two large screens of the same size, with one sequence shown upside-down. Increasing the scale from the intended intimate, domestic to the monumental, slowing the pace, removing the sound, all effectively strip the work of its erotic potential: the stripper's movements become hypnotic rather than suggestive, perhaps still able to alter the viewer's state of mind but not necessarily in the sense originally intended.

Gordon did, however, create some works around this time that made direct use of or reference to mainstream cinema: a group of works sharing the title *The End* 1995, along with the single-screen video installation *Remote Viewing 13.05.94 (Horror Movie)* 1995. *The End (Split-Second Configuration)* (fig.35) presents two scannerchrome images on canvas, taken from the final scene of Don Siegel's *Invasion of the Body Snatchers* (1956). Significantly, they adopt the ratio of the TV rather than the movie screen. During the screening of the film, these two images would be separated from each other by a split second. Thus the work poses questions about the moment and even existence of finality and release, implying the same concern with an expanded sense of time and endlessness that appears in many of Gordon's works, including *Remote Viewing 13.05.94 (Horror Movie)* (fig.36), his first work to feature original footage. The scene is based on a brief moment in John M. Stahl's film *Leave Her to Heaven* (1945), which though shot in colour is nonetheless noir in its depiction of *amour fou*, jealous rage and deadly violence. Gordon's large-scale

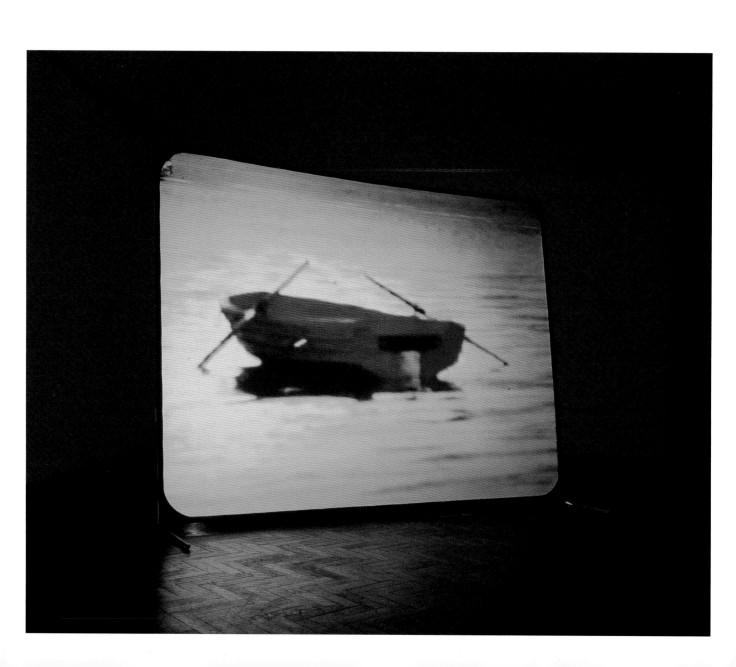

REMOTE VIEWING 13.05.94
(HORROR MOVIE) 1995 [36]
Video installation with short-wave
radio
Screen size:
400 x 300 (157 1/2 x 117 3/8)
Installation view: 'Wild Walls',
Stedelijk Museum, Amsterdam 1995
Collection Stedelijk Museum,
Amsterdam

video projection also relies like the original film on lush colour: housed in a deep red room, the footage shows a small rowing-boat, of the same colour as the room, drifting unmanned on the water, accompanied by the noise from a radio stuck between stations. It is an atmospheric, perpetual moment of continual dramatic tension, refusing resolution.

But the most epic and enduring film-related project Gordon undertook at this time was his 5 *Year Drive-By* (figs.37–9). First realised in part for the 1995 Lyon Biennale, where it ran for the three months of the exhibition's duration, this ambitious project has spanned several years. Gordon wanted to make this 'something of a companion piece to 24 *Hour Psycho*'. His plan was to take John Ford's classic Western of 1956 *The Searchers* and extend it from its actual 113 minutes to the five-year period covered by the film's narrative. *The Searchers* tells the story of a man (played by John Wayne) on a relentless five-year search for his niece, abducted by Comanches at the beginning of the film. It is one of the first films Gordon remembers ever having watched, seen at home, on television with his parents when he was around six or seven years old. He claims to have been struck even then by the extraordinary simplicity of the narrative: 'I remember asking my father how a film could be made that seemed to be about nothing.' His father explained that it was not about nothing but rather about searching and hoping and waiting. 'A few years later I saw the film again; this time with the foreknowledge of the narrative and that nothingness could be seen to be significant to older people even although what I really wanted was a lot more shooting and killing than the film appeared to contain.' Gordon's realisation that the film is precisely about the passage of time led him to the idea for the work, almost as a tribute to the truly epic quest and to the suffering of Wayne's character.

'How can anyone even try to sum up five miserable years in only 113 minutes?' The calculation as to how the five-year-long version would work equates 113 minutes of cinema time with 2,629,440 minutes in real time, which, given the standard film projection speed of 24 frames per second, means that in Gordon's version there are only an excruciating 3 frames per hour. 5 *Year Drive-By* was later realised in part in Hannover in 1997 as a one-off, overnight screening, from sunset to sunrise, a period of approximately eight hours, which, according to Gordon's calculations, would mean just over one second of time in the original film. It is finally being rendered in its entirety in Oslo, where it will run for the intended five years.

The imagined world of Gordon's pre-natal self, first visited in *Something between my mouth and your ear* (fig.23), two years earlier, recurs in *Words and Pictures* 1996 (fig.46), which creates a relaxed, social setting in which a selection of video tapes can be watched. The library from which they can be chosen is compiled from a list of films that were shown in cinemas in Glasgow between 20 December 1965 and 20 September 1966, again the nine months prior to his birth. The list includes familiar classics of the day, like *The Sound of Music* (1965), *The Magnificent Seven* (1960) and Hitchcock's *Marnie* (1965) as well as less enduring creations such as *Daleks-Invasion Earth 2150 A.D.* (1966). There is also a smattering of 'pop' movies and genres: Presley movies, films featuring The Beatles, and the Sean Connery Bond film, *Thunderball* (1965).

Cinéma Liberté 1996 (figs.40–2) (a work realised in collaboration with the artist Rirkrit Tiravanija in Montpellier, has a similar setting, an ad hoc cinema reached through a bar, equipped with a video monitor relaying whatever was being played in the upstairs space. Here, a selection of films previously unavailable or censored was available, including cinematic classics

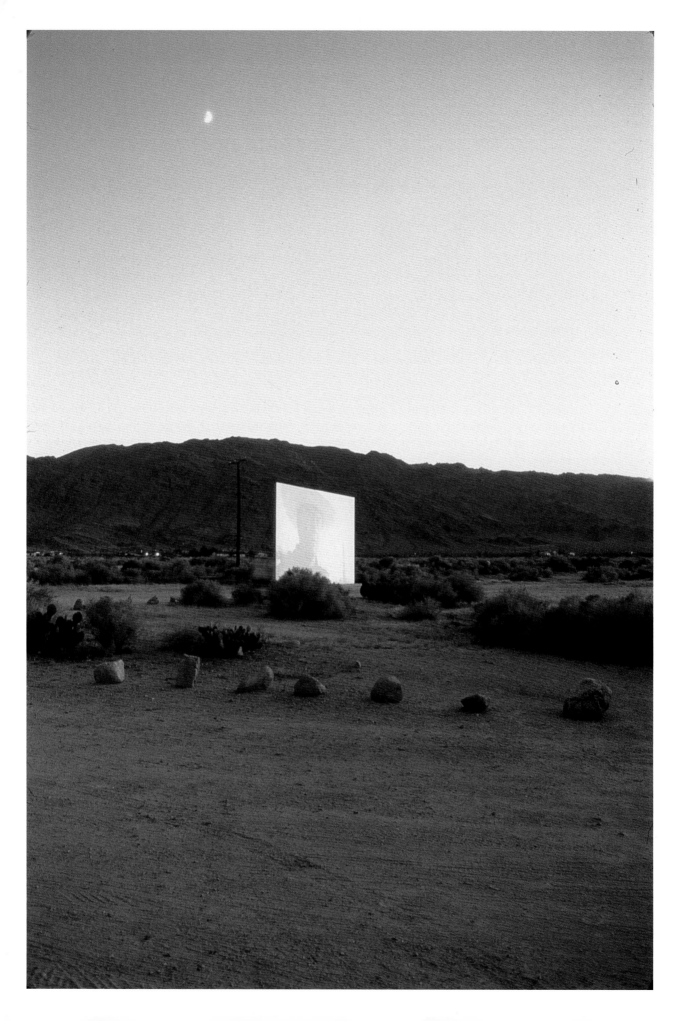

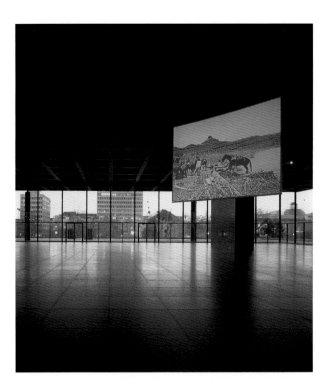

5 YEAR DRIVE-BY 1995 [37]
Video installation
Dimensions variable
Installation view: '5 Year Drive-By',
Twentynine Palms, California 2001
Collection Telenord, Oslo
Courtesy of the artist and Gagosian
Gallery, New York

5 YEAR DRIVE-BY 1995 [38, 39]
Video installation
Dimensions variable
Installation view:
Neue National Galerie, Berlin
Courtesy of the artist and Gagosian
Gallery, New York (top) and the
artist and DAAD, Berlin (bottom)

such as *Nuit et Brouillard* (Night and Fog) by Alan Resnais (1955) and *Et Dieu Créa la Femme* (And God Created Woman) by Roger Vadim (1956). Crucially, *Cinéma Liberté* shares with *Black and White (Babylon)* (fig.34) a use of the illicit to expose the bounds of social and cultural acceptability, while the format sets up another control relationship, whereby viewers upstairs dictate what those downstairs are watching.

The focus of much of Gordon's work prior to this time had been the individual, the inner self, albeit as manifest in a social context. *Cinéma Liberté* engages, however, with a more overtly public domain and points to a shift that was to come into play with a group of works first shown at the Migros Museum für Gegenwartskunst, Zurich in 1996. Using innocuous yet illegal, low-grade recordings of rock concerts from which they take their collective title, the group of *Bootleg* videos raises questions of what is permitted, what is allowed to enter consciousness and what is regarded as dangerous. They look at what and why things are kept from view. While the illegality of 'bootleg' films stems from commercial rather than moral concerns, they similarly exist outside the realm of the socially acceptable. In many areas of life, censorial voices decree that anything liable to induce or encourage antisocial behaviour is unacceptable and therefore proscribed or at least controlled. Restrictions are put in place and laws devised to minimise the possibility of irresponsibility, of mass states of hysteria, of anarchy. But one area in which otherwise frowned-upon behaviour is permitted, even expected, is live rock performance.

The relationship between rock and euphoria was first discussed in the context of an artwork in Dan Graham's seminal *Rock My Religion* 1982–4, which likens the ecstatic experience of rock concerts to the rituals of various religious sects. The connection with

Douglas Gordon and Rirkrit Tiravanija
CINÉMA LIBERTÉ BAR LOUNGE 1996
(top and middle) [40 and 41]
Video installation and bar
Installation view: 'Douglas Gordon &
Rirkrit Tiravanija', FRAC Languedoc-
Roussillon, Montpellier 1996
FRAC Languedoc-Roussillon,
Montpellier

Douglas Gordon and Rirkrit Tiravanija
CINÉMA LIBERTÉ BAR LOUNGE 1996
(bottom) [42]
Video installation and bar
Installation view: 'Manifesta I'
Rotterdam 1996
FRAC Languedoc-Roussillon,
Montpellier

Graham's work is acknowledged in the Zurich exhibition catalogue, which cites, for example, Graham's comments on Patti Smith, who 'associated rock music with the ecstatic religious Circle Dance of the Shakers, the dance of the Whirling Dervishes of Morocco, and the Ghost Dance of the Native American'. Gordon's three *Bootleg* works bring an awareness of this history together with his established interest in the troubled psychic being. Both the material used and the behaviour depicted lie outside the norm, but the works' focus is not just on the ecstatic states depicted: it is simultaneously on the relationship between performer and crowd, between star and anonymity. *Bootleg (Bigmouth)* (fig.43) and *Bootleg (Cramped)* (figs.44–5) each comprise low-grade, grainy footage of a different exuberant and idiosyncratic performer, while *Bootleg (Stoned)* records the crowd's reaction to a third. The two visible figures are Morrissey of the Manchester band The Smiths, the epitome of teenage angst and fey introversion who appears in *Bootleg (Bigmouth)*; and the infamously outrageous Lux Interior, singer with The Cramps who features in *Bootleg (Cramped)*. Radically different in many ways, not least in their music, Morrissey and Interior are almost perfect symbols of opposite extremes of sexual behaviour. Morrissey is known for his celibacy and (off-stage) reclusiveness, while Interior (his real name is Erick Purkhiser) combines overtly sexual, aggressive and suggestive behaviour on stage with a general notoriety for transgressing the limits of acceptability off it. Appearing here bare-chested, wearing shiny trousers and high heels, he was once brilliantly described as 'a cross between Elvis and Frankenstein's monster'. The punk-influenced music of The Cramps, one of the mainstays of the renowned CBGB club in New York in the late 1970s and 1980s, was referred to as 'twisted

BOOTLEG (BIGMOUTH) 1996 [43]
Video installation
Migros Museum für
Gegenwartskunst, Zurich

BOOTLEG (CRAMPED) 1995 [44]
Video installation
Installation view: Centre Georges
Pompidou, Paris 1995
Migros Museum für
Gegenwartskunst, Zurich/Courtesy
of the artist and Lisson Gallery,
London

BOOTLEG (CRAMPED) 1995 [45]
Video installation
Installation view: Centre Georges
Pompidou, Paris 1995
Migros Museum für
Gegenwartskunst, Zurich/Courtesy
of the artist and Lisson Gallery,
London

and psychotic rock-a-billy'. Their 1984 album was entitled *Bad Music for Bad People. Bootleg (Stoned)* (fig.47), meanwhile, involves two screens, each showing slowed-down footage, filmed illicitly from the midst of the crowd at a Rolling Stones concert at the Albert Hall in 1966, the year of Gordon's birth. The London event followed their famous concert in the Netherlands where the first-ever stage invasion had happened. All we see, however, is a tiny moment, less than two seconds' worth, of the ecstatic crowd, arms waving in the air. The absent instigator of their frenzy is Mick Jagger, the archetypal darling/demon of British rock, now transformed in public perception from the corrupter of youth and a drug-addled criminal to honoured veteran performer.

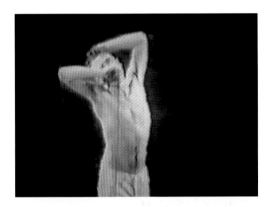

Both stars and crowd display a mesmeric twitching and writhing not dissimilar to that brought about by the psychoses of the patients who appear in other works. Their mania is, however, voluntary, conscious and, significantly in terms of Gordon's work, enacted in public. They have given themselves over to an external force, namely the music. In *Bootleg (Stoned)*, deprived of the source of the crowd's ecstasy, the viewer can only see them as in the grip of some primal force. The slow, hypnotic pace makes this familiar behaviour seem strange, even troubling. The association of dance with demonic possession that Graham included in his work is not far away. Such ideas can be traced far back in history. In a fabulously titled text *An Arrow against Profane and Promiscuous Dancing Drawn out of the Quiver of the Scriptures* (1684), for example, the seventeenth-century American Puritan Increase Mather wrote, 'a Dance is the Devil's procession. He that enters into a Dance, enters into his possession.' Using the Bible as justification for the suppression of wanton dancing, he expresses a belief that succumbing to one's bodily

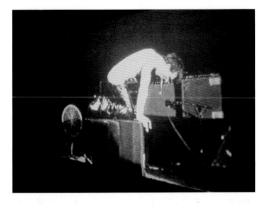

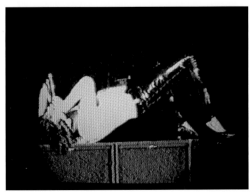

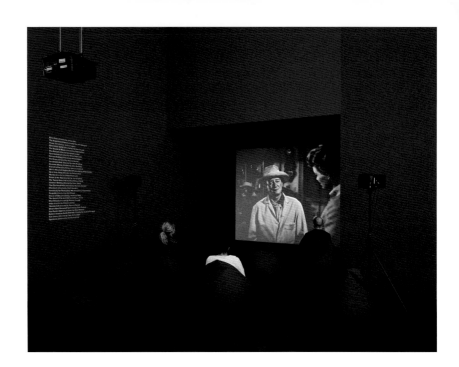

WORDS AND PICTURES, PART 1
1996 [46]
Video installation
Installation view: 'The Oldest
Possible Memory', Hauser and Wirth
Collection, St Gallen 2001
Hauser and Wirth Collection,
St Gallen

impulses is evil, propagating the concept of a divide between body and spirit, sex and soul, that is equated with the divide between the bestial and celestial. Through Gordon's works, we come to see music as a socially acceptable drug, a mind-altering means of inducing abnormal behaviour, behaviour more manic than euphoric. As with so many of Gordon's works, and in particular his *Letters*, this work plays on the very edges of accepted social behaviour. The familiar ritual enacted in these films becomes strange and troubling, too close to the uncomfortable spectacle of madness. He seems to be asking what constitutes the mad, the manic, the bestial, and more importantly the undesirable, the socially reprehensible.

Brought together in the Zurich installation with *Trigger Finger* (fig.28) and *Film Noir (Hand)*, the effect was a questioning of ascribed abnormality. The characteristically spirited performances, the delirious crowd's uniform hysteria and the trauma victims' compulsive behaviour share a sense of possession, of being out of control, occupied by something other than the 'normal' self. The juxtaposition of the two types of footage also draws attention to the hand: it appears both as means of expression and as source of the transformative touch. The *Bootleg* works seem to stress the desire for physical connection; the audience members clamouring for Morrisey's touch in *Bootleg (Bigmouth)* (fig.43), for example, does not seem so far removed from the religious practice of laying on hands. While together, the works tended to emphasise the physical energy depicted as an expression of the psychic self, a fusion of the two types of being. The objectifying gaze is common to all and the question the exhibition seemed to ask was: can a distinction be made between the wilfully enraptured and the psychologically scarred?

The wilful alteration of states of mind through music and film has been an enduring attraction to Gordon. His awareness and understanding of the physical experience of entering a darkened room has led to a strategy by which he reduces, in his work using sound and video, the information available to the audience to help understand a new environment. He examines how this affects both one's own behaviour and one's relationship to other individuals. The heightened psychological states manifest in or even induced by some of the footage he uses take the viewer outside of accepted norms, transporting us from the controlled calm of the everyday to more disturbing and uncertain terrain. With the *Bootleg* works Gordon asks what happens when what might be problematic for an individual is translated to a mass, public arena. This is territory Hitchcock himself acknowledged in the effect of his work: 'I feel it's tremendously satisfying for us to be able to use cinematic art to achieve something of mass emotion.'

How inner states, emotional and psychological, are discernible on the external surface of the body is at the crux of the *Film Noir* and *Bootleg* series (fig.32, and figs.43–5, 47), as well as of *Trigger Finger* (fig.28), *Hysterical* (fig.30) and *10ms^{-1}* (fig.29), where this was the scientific motive behind the original footage. Despite this search for the physical location of the psychic self, they each point to a perceived opposition between body and mind. This split has attracted scientists, philosophers and artists for centuries, resulting in a vast range of theories as to what the correct balance ought to be. It is inevitably linked with the weighty issues of right and wrong, life and death, good and evil that continually permeate Gordon's work.

BOOTLEG (STONED) 1996 [47]
Video installation
Migros Museum für
Gegenswartskunst, Zurich
Courtesy of the artist

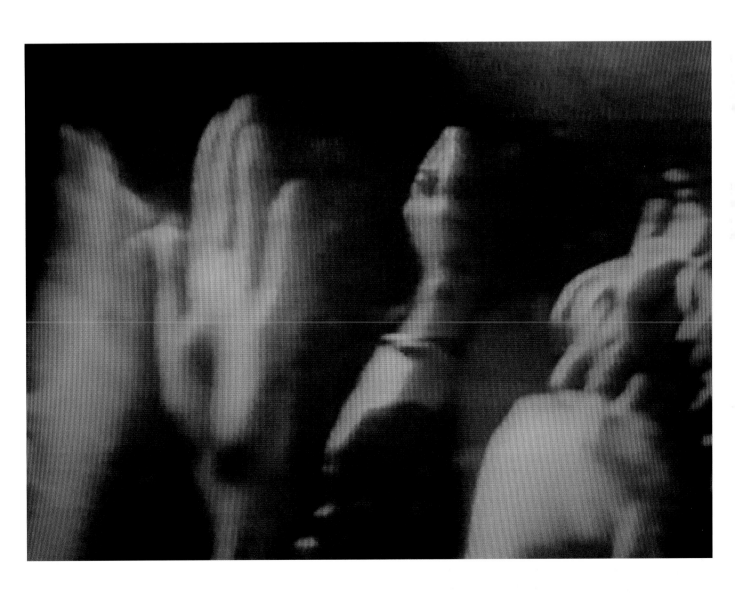

First developed as part of a larger installation entitled . . . *head* shown at the
Uppsala Konstmuseum in Sweden, *30 Seconds Text* is one of the best examples of
Gordon's extraordinary combination of highly resonant and powerful material
with a simple but precisely controlled physical space. The work is comprised of
two elements: a text rendered in white vinyl on one wall of a black room and
a single bare light bulb, controlled by a timer to illuminate the space for thirty
seconds at a time, before plunging it into darkness for the same duration. The text
is a factual description of an experiment carried out in Montpellier in 1905 by a
Dr Baurieux, whose aim was to determine if human consciousness survived
physical death. The doctor in question sought to communicate with a decapitated
head immediately after its severance.

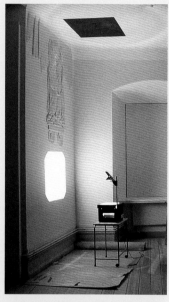

I showed . . . head *only once . . . because I was too shocked by the images. The context in
Uppsala was the castle, the old building that's part of the museum in this old university
town. I was fascinated by the rooms which had been renovated . . . At a certain point
there was a relief of an angel. They just cut his head off. That was very strange – the
image of an angel without a head. I was shocked that they would be that cruel to such
a beautiful piece of decoration . . . So I projected* 30 Seconds Text *on the feet of the
decapitated angel. That was the first room. In the next one, there was a projection
screen that showed the photo of a head that had been cut off. But you could only see it
once you had read the text . . . Then in the last room you could see the body without the
head – also as film. The images were not clear at all, sometimes focused, sometimes not.*

30 SECONDS TEXT [48]
Overhead projector
Installation view: 'Sawn Off', Uppsala,
Konstmuseum 1996
Goetz Collection, Munich; Private
Collection, Amsterdam

Removed from the exceptional context of the castle at Uppsala, and the angel that
had prompted it, the work took a simpler form to powerful effect. It was first
shown in its new form in the exhibition *Life/Live* at the Musée d'art moderne de
la Ville de Paris. A light bulb, suspended in the space just above head height, was
introduced as a surrogate angel. It is illuminated for the same amount of time as
the head of the executed criminal in Dr Baurieux's experiment, Languille, is said
to have retained consciousness, which in turn is just long enough to read the text.
The effect is to fuse two distinct time frames: that of the experiment and that of
the viewer's experience of the piece. When the light goes out, leaving the viewer
cut off from a visual awareness of the space, he or she is left in complete darkness.
It is an anxiety-inducing moment, in which a new relationship with the room has

to be quickly established, one that is primarily about the identification of the means of escape. It plays, as Gordon has said, on a childhood fear of the dark and the fact that time seems to pass more slowly when the lights go out.

30 Seconds Text is the very epitome of the conjunction and coalescence of body and mind, feeling and reason. It displays an extraordinary interconnectedness of form and content; the form of the work is alternately cerebral (the reading of the text) and physical (the disorientatingly dark space), while its content is likewise both scientific and emotive. It recalls *Something between my mouth and your ear* (fig.23), both in terms of what happens during the process of reading – the internal, penetrative activity involved – and the creation of a specific physical environment in which attention is focused on that internal space. Once the text has been read, the viewer is left to digest it, shocked and disorientated, standing in the dark with the powerful spectre of a talking severed head.

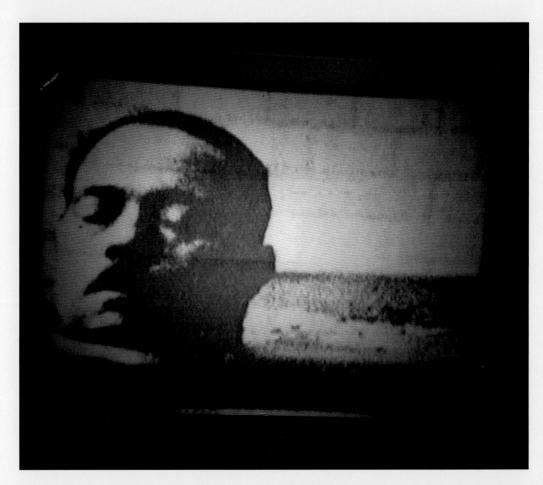

30 SECONDS TEXT 1996 [50]
Timer, light bulb, wall text
Dimensions variable
Goetz Collection, Munich; Private
Collection, Amsterdam

30 seconds text.

In 1905 an experiment was performed in France where a doctor tried to communicate with a condemned man's severed head immediately after the guillotine execution.

"Immediately after the decapitation, the condemned man's eyelids and lips contracted for 5 or 6 seconds…I waited a few seconds and the contractions ceased, the face relaxed, the eyelids closed half-way over the eyeballs so that only the whites of the eyes were visible, exactly like dying or newly deceased people.

At that moment I shouted "Languille" in a loud voice, and I saw that his eye opened slowly and without twitching, the movements were distinct and clear, the look was not dull and empty, the eyes which were fully alive were indisputably looking at me. After a few seconds, the eyelids closed again, slowly and steadily.

I addressed him again. Once more, the eyelids were raised slowly, without contractions, and two undoubtedly alive eyes looked at me attentively with an expression even more piercing than the first time. Then the eyes shut once again. I made a third attempt. No reaction. The whole episode lasted between twenty-five and thirty seconds."

…on average, it should take between twenty-five and thirty seconds to read the above text.

Notes on the experiment between Dr. Baurieux and the criminal Languille (Montpellier, 1905) taken from the Archives d'Anthropologie Criminelle.

A DIVIDED SELF II 1996 [51]
Video installation
Dimensions variable
Fondazione Re Rebaudengo-
Sandretto, Turin; Jack and Nell
Wendler, London;
Andrea Nasher, New York

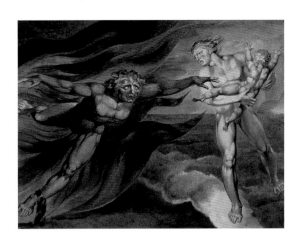

William Blake
THE GOOD AND EVIL ANGELS
c.1795 [52]
Colour print finished in ink
and watercolour on paper
44.5 × 59.4 (17 ½ × 23 ⅜)
Tate

THE DIVIDED SELF

Age-old philosophical debates about the distinction between body and soul, traditionally cleaving a being into physical and cerebral selves, tend to share a view of the body as being linked with base, animalistic, sexual tendencies, while the soul or mind is connected to the rational, spiritual or moral self. Abnormality, even madness, is considered the result of an excessive imbalance between the two, yet one without the other would be meaningless. Philosophy, theology and psychology all engage variously with understanding the relationship between the two, with differing definitions and rationales, while the psychiatry that has informed Gordon's work can be thought of as looking at the imbalances, the 'disorders' made known via behaviour. William Blake proposed a particular understanding of the ideal relationship between the two, his images such as *The Good and Evil Angels* c.1795 (fig.52) illustrating what he saw as the error of allowing reason to reign supreme. He was more inclined to see physical energy as a positive force. Whatever the balance, the two are utterly inter-dependent: though Languille's severed head remained communicative, it was not for long.

This kind of tussle between interconnected, co-dependent but opposing forces is a key theme for Gordon, most explicit perhaps in the exhibition he presented for the Turner Prize at the Tate Gallery in 1996. He brought together a group of new works, using both text and video, all sharing a striking duality. The first of these are *A Divided Self I* and *II* 1996 (fig.51), a pair of video works shown on monitors. On each, two arms can be seen struggling with each other for dominance. One is smooth-skinned, the other dark and hairy (both are in fact Gordon's). It becomes clear that this is not a combat in which a victor and vanquished will emerge, but rather an endless exchange between two entities.

The work takes its title from an influential book published in 1960 by the innovative Scottish psychiatrist R.D. Laing (1927–1989). Becoming a best-seller in the late 1960s, the book sought to capture the true structure of the schizophrenic experience, something Laing himself had undergone earlier in his life. His work in the 1950s and 1960s was dedicated to trying to find new ways of dealing with schizophrenia – in terms both of better understanding and better management of the condition. He attempted to devise a new practice of psychiatry that would not follow the established practices – which Michel Foucault had astutely criticised as 'a monologue of reason about madness' – but would rather allow for a real *dia*logue, a two-way conversation. In 1953 Laing set up a 'Rumpus Room' in the Glasgow hospital in which he worked, a space where patients and staff could come together in a social setting. This project was later to inform his participation in the famous 'Kingsley Hall' project in London of the late 1960s. This set up a non-hierarchical community, whereby staff co-existed with patients, working through the latter's psychoses without resort to drug therapy or surgery.

The ideas pursued by Laing form a thread that runs through several of Gordon's works at this time, particularly those that came together in the Turner Prize exhibition. In *The Divided Self*, Laing specifically discusses cases in which people 'have come to experience themselves as primarily split into a mind and a body'. He explains two ways of being: *embodied*, with an awareness of one's physical substance and existence, and *unembodied*, in which the body is felt to be removed from the self, which becomes more like an onlooker to the body's behaviour. He suggests that the possibility of dysfunction, of psychosis, is always present 'if the individual begins to identify himself too exclusively with that part of him which feels unembodied'.

4

Gordon's reference to Laing in the title is significant not only for its thematic connection with his ideas, but also as a further example of the role played by text in his work. Many of his works bear titles that are almost extensions of the work itself – they sit within it, not outside it, acknowledging the part they play in our developing relationship with the work and our consciousness at the time of the encounter. *Something between my mouth and your ear* (fig.23), for example, sets up a level of intimacy, even secrecy, a shared confidence between artist and viewer, while *Film Noir* (fig.32) establishes a connection with a particular genre of cinema and our expectations thereof, although the footage used in the work is from a quite different source.

The second work included in the Turner Prize exhibition, *Untitled Text (for someplace other than this)* 1996 (fig.53) pursues Gordon's appreciation of language and the playful subversion of its supposed certainties. White text on a dark blue wall that wraps neatly around a corner describes a world turned upside down. It lists values and qualities each negated by their opposite, from the straightforward ('open is closed', 'nature is synthetic') to the more emotive ('life is death', 'hate is love', 'lunacy is sanity'). This presents a controlled picture of chaos, of turmoil, of rupture and confusion, as if affected by extreme emotion. At the dead centre of the text, standing slightly apart from the rest of the lines is the phrase: 'fulfilment, I am you, you are me, fulfilment'. Before and after this line lie the words 'desire', 'desire is fulfilment'. In the second half, the list of opposites is repeated, each phrase now inverted, so that 'hot is cold' becomes 'cold is hot' and so on. Reading the text from start to finish is like a two-way journey, into the centre and back out again, with the point of arrival – 'I am you, you are me' – being the only one where the neat inversion of

opposites does not function linguistically. 'I' has to become 'me'. The 'you' that lies, doubled, at the work's heart, the perfectly mirrored object, demands a change to the authorial position. The whole piece literally and metaphorically pivots around you. Bracketed by fulfilment, the crux of the work recalls Laing's notion of complementarity, whereby 'the other is required to complete the self'. Ironically, the self can only be fully defined and established at the point of congress with another, a paradox similarly described by Georges Bataille. He wrote that sexual union brings about an indistinguishability between two otherwise distinct beings. Only in an intimate relationship with another can the self be complete. What both Laing and Bataille suggest is that there can be no such thing as an autonomous self-defined being and that desire, a fundamental human emotion, once satisfied, brings about a degree of self-annihilation at the same time as it delivers any sense of completion.

The need for completion and definition through the other, through the confusion of opposites, underpins *Untitled Text*. It also recalls the emotional tone and suggested breakdown that comes across in many of the *Letters* and *Instructions*, several of which allude to disclosure, intimacy and imminent dramatic change or upheaval: 'You can't hide your love forever' (*Instruction Number 1*, March 1992), 'Nothing will ever be the same' (*Instruction Number 6*, May 1993), 'Life or death' (*Letter Number 6*, 6 April 1992).

The (con)fusion of two beings is most explicit in what is also the most physically imposing of the three works, *Confessions of a Justified Sinner* 1995–6 (fig.54). Comprising two large projection screens in a darkened space, the work fuses two great works of Scottish fiction, one world-renowned and the other more obscure. The first is Robert Louis Stevenson's classic horror story *The Strange Case of Dr Jekyll and Mr Hyde*,

... hot is cold, day is night, lost is found, everywhere is nowhere, something is nothing, pain is pleasure, blindness is sight, hell is heaven, confinement is freedom, black is white, inside is outside, famine is surplus, bad is good, nature is synthetic, life is death, fiction is reality, equilibrium is crisis, doubt is faith, hypocrisy is honesty, feminine is masculine, open is closed, neglect is cultivation, laughing is crying, contaminated is pure, blessing is damnation, construction is demolition, blunt is sharp, sweet is bitter, satisfaction is frustration, depression is elation, nightmares are dreams, flying is falling, water is blood, truth is a lie, hate is love, trust is suspicion, shame is pride, sanity is lunacy, outside is inside, forward is backward, shit is food, dark is light, right is wrong, left is right, future is past, old is new, losing is winning, work is play, attraction is repulsion, screaming is silence, desire is fulfilment, I am you, you are me, fulfilment is desire, silence is screaming, repulsion is attraction, play is work, winning is losing, new is old, past is future, right is left, wrong is right, light is dark, food is shit, backward is forward, inside is outside, lunacy is sanity, pride is shame, suspicion is trust, love is hate, lies are truth, blood is water, falling is flying, dreams are nightmares, elation is depression, frustration is satisfaction, bitter is sweet, sharp is blunt, demolition is construction, damnation is blessing, pure is contaminated, crying is laughing, cultivation is neglect, closed is open, masculine is feminine, honesty is hypocrisy, faith is doubt, crisis is equilibrium, reality is fiction, death is life, synthetic is natural, good is bad, surplus is famine, outside is inside, white is black, freedom is confinement, heaven is hell, sight is blindness, pleasure is pain, nothing is something, nowhere is everywhere, found is lost, night is day, cold is hot...

CONFESSIONS OF A JUSTIFIED SINNER
1995–6 [54]
Video installation
Installation view: Fondation Cartier
pour l'Art contemporain, Paris
Collection Fondation Cartier, Paris

published in 1886, of which director Rouben Mamoulian's 1932 film version provides the footage. The second is the earlier lesser-known work by James Hogg, *The Private Memoirs and Confessions of a Justified Sinner*, published in 1824, which lends the work its title. Stevenson's tale is the classic Gothic story of the good Dr Jekyll's struggle with his evil alter-ego, Mr Hyde, a murderous creature brought into (his) being by the ingestion of some strange chemical potion. Hogg's tale is similarly concerned with the split personality, but in this case the demonic is more directly religious than scientific, as much of the basis for the events of the story is grounded in interpretations of the Bible. The use and abuse of the written word to substantiate actions is the core of the tale's unfolding, the origin of the 'justification' of the title. While Hogg's anti-hero, the demonic Gil-Martin, finds his logic in the Bible, Jekyll's is scientific experimentation. Both tales are told in more than one voice – that of the author of a 'found confessional' and that of its editor, who makes apology for the horrors being brought to light.

The footage used in the work is an excerpt from the moment of transformation, the hideous contortions and disfigurations undergone by Jekyll as he becomes Hyde and vice versa. The camera focuses on his head and his hand, which at one point reaches for the neck, as if one 'self' were trying to kill the other. Gordon's extract is looped continuously so that the being before us never coalesces into one or the other. It is an endless cycle of metamorphosis in which the two selves are always present in varying degrees.

Stevenson's text and Gordon's work both play to our social and cultural desire to grasp a personification of evil, with the (futile) hope that being able to identify it may strengthen attempts to combat it. *Confessions of a Justified Sinner* resists that finality, insisting on uncertainty and refusing an absolute vision, of evil or indeed of good. As long as the two forces are present at the same time and in the same physical being, the one cannot be extracted from the other. The quest for visual identification, to understand from appearance alone, goes back again to nineteenth-century psychiatry and its early uses of photography, particularly in the work of Charcot. Perhaps more specifically it recalls the related work of Francis Galton, whose belief in biological determinism led him during the 1880s to produce 'composite photographs' of criminals in an endeavour to establish a criminal physiognomy that would enable the identification of actual and potential criminals by facial appearance alone. These superimpositions of as many as fifteen images of criminals of course produced a composite that had no remarkable characteristics whatsoever, the process having eradicated any distinguishing features. Galton's now discredited work is one of the first examples of attempts at visualising the very face of evil. It is a fascination that remains with us, still evident in the repeated reproduction in the media of the images of those associated with horrendous crimes, from 'moors monster' Myra Hindley to Osama Bin Laden.

This cultural fixation with the monstrous, the marginal, the outcast, the degenerate – with all that is the antithesis of the socially acceptable – and the faith in visual identification run throughout Gordon's work of this period, from *Confessions of a Justified Sinner*, in which the original film uses a comparable technique of superimposition to that of Galton, to his treatment of his own appearance in a number of photographic works. At the time of the Turner Prize, he provided the Tate with a photograph of himself for publicity purposes. The image he sent was a simple passport photo of an expressionless Gordon, half-hidden under

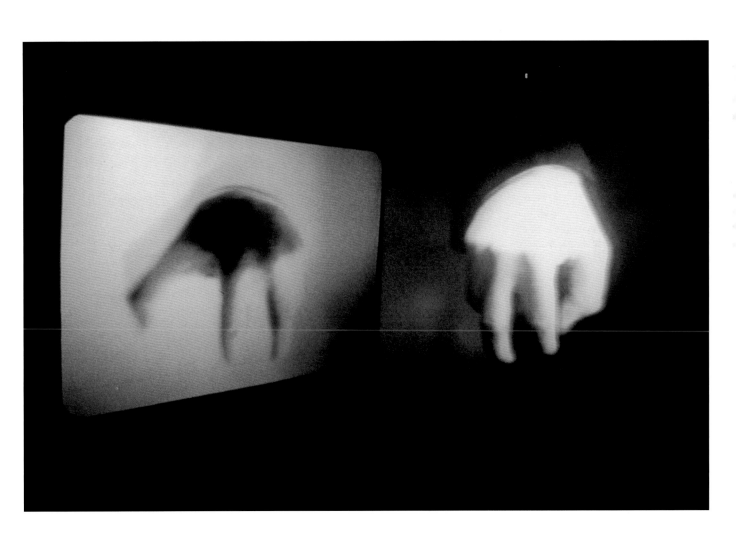

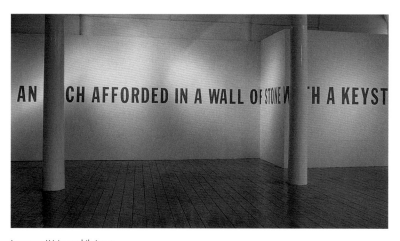

Lawrence Weiner exhibtion at
Transmission Gallery, Glasgow 1991
[55]

a crooked, cheap blond wig. With this dead-pan mug shot, Gordon sought to obfuscate the process of identification, at the very moment when he was being put up for mass exposure. Titling the photograph *Self-Portrait as Kurt Cobain, as Andy Warhol, as Myra Hindley, as Marilyn Monroe* 1996 (fig.56) he was hiding behind the other identities referenced, introducing his own Galton-like layering in the title. Each of these individuals somehow stands outside the norm. Between them their reputations encompass many of society's enduring *bêtes noires*: sex, drugs, rock 'n' roll, suicide, murder, unconventional sexuality.

Gordon's catalogues and books are full of textual equivalents of this strategy of controlled revelation: a letter from one of his brothers, sent 'by way of a statement on the artist's behalf' to the curators of an exhibition at the Stedelijk Museum in Amsterdam in 1995; the anonymously authored narrative *Short Biography – by a friend* that appears in the 1998 catalogue of his exhibition at the Kunstverein Hannover; and the similarly anonymous and extraordinary *Ghost: The Private Confessions of Douglas Gordon* published in the book that accompanied his 2002 exhibition at the Hayward Gallery, London, as well as several letters and short texts recalling visits to different cities or overheard stories (he does love a good story). Whatever format they adopt, these narratives are distinct from the confessional art that had begun to appear in the early 1990s, in as much as Gordon's are not emotional outpourings. The incidents they recall often seem too fantastical to be true, too out of the ordinary to be real experiences, yet they are recounted in a matter-of-fact tone. They force the reader to think about fact and fiction, reality and fantasy. Are they what they purport to be? Did the events they describe really happen? Does it matter if they exist only as fantasy? How does it affect our relationship with the artist's work if none, or all, of this is true?

There are facts to be gleaned from these texts, especially the *Short Biography – by a friend*. He was born in September 1966, grew up and was educated in and near Glasgow, in the midst of the Catholic –Protestant sectarianism that any of us schooled in the city know too well. He has two younger brothers and a sister. His mother, Mary, left the Church of Scotland to become a Jehovah's Witness in the early 1970s and his father, Jim, was a pattern-maker for the ship-building industry on the Clyde and plays the bagpipes. While he was at school he had an evening job in a supermarket, and watched lots of movies on TV. He went to art school in Glasgow and then on to the Slade in London for two years before returning to Glasgow, where he got involved in the artist-run Transmission Gallery (where he organised a show with Lawrence Weiner, among others, see fig.55). He went to live in Germany, initially for a year, in 1997, first in Hannover and then in Berlin. These, and other things, I know to be true. But what do they mean in terms of how we regard his work as an artist? That's a different question, and one posed by Gordon's approach to the story of his own life. His texts seemingly set out facts, but actually they proceed to set up an intrigue. André Malraux once suggested that an author's process of *intriguing* the reader 'tends to make someone believe something: every intrigue is an architecture of lies'. Resisting the habitual reliance on biographical landmarks to stray into the realm of fantasy, these statements, stories and biographies are as much part of that controlling aspect of Gordon's practice and of how he projects himself into the world as the work itself.

Gordon appears again in *Monster* 1996–7 (fig.57), this time transforming his face into something grotesque and monstrous with the simple application

MONSTER 1996–7 [57]
Transmounted C-print
95.3 × 127 (37 ½ × 50)
Charles Asprey, London

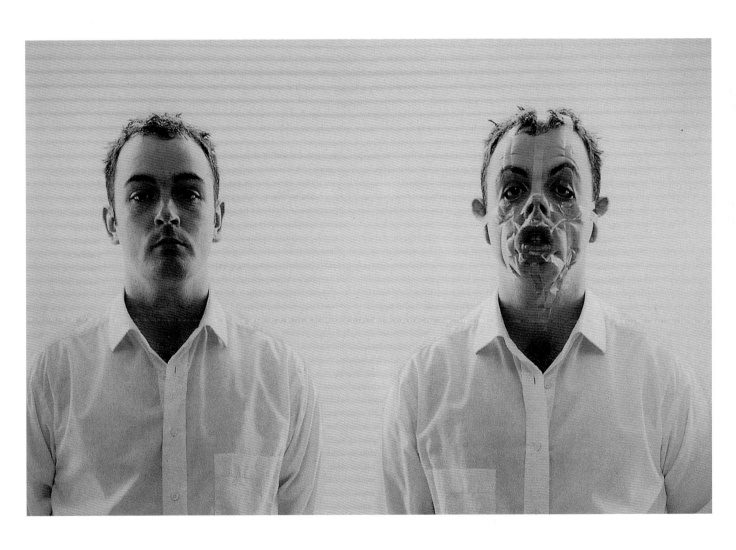

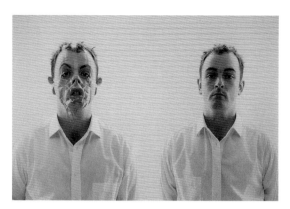

MONSTER REBORN 1996/2002 [58]
Transmounted C-print
95.3 x 127 (37 ½ x 50)
Courtesy Patrick Painter Editions

FROM GOD TO NOTHING
1996 [59, 60]
Wall text with lightbulbs
Dimensions variable
Installation view: 'Here + Now',
Generator Projects, Dundee 2001
FRAC Languedoc-Roussillon,
Montpellier

of strips of Sellotape. He contorts his own features into a beastly version of himself. There are currently three versions of the work. The first is photographic, two straight 'before' and 'after' shots of Gordon in a white shirt, squeaky clean with his hands behind his back, posed as for a formal portrait. The second is a video recording his gradual transformation, revealing the stage-by-stage descent into hideousness. The third, entitled *Monster Reborn* 1996/2002 (fig.58) is a mirror-image photographic print of the first, reversing the transformation from left to right. But which is the real monster? This humorous piece pokes fun at our readiness to judge by appearances and our fear of the physically abnormal. But it also highlights the dislike of the dis-alike, our fear of the unknown.

With these works Gordon invokes not just the desire to see that which is evil or degenerate, but the cultural fascination generated by monstrous figures. They draw attention to the push/pull dichotomy of repulsion and compulsion manifest in the preponderance of films, TV programmes and books that seek to provoke fear, even if experienced in the comfort of a safe domestic or public environment. The enduring appeal of crime fiction and the rise of the drama-documentary, hovering between fact and fantasy, suggest an unpleasant hunger for horror, a

need for the stimulation provided by fear, by the extraordinary, the outrageous. Completed during a DAAD (German Academic Exchange Service) residency in Hannover, *From God to Nothing* 1997 (figs.59–60) was first shown, in a suggestive 'fear and sex' pairing, along with *Black and White (Babylon)* (fig.34) at Galerie Micheline Szwajcer in Antwerp. The work lists 147 of Gordon's fears, from 'fear of God' to 'fear of nothing', covering the familiar or commonplace (fear of spiders, fear of falling, fear of dying, fear of the dark) to the strange and dis-concerting (fear of laughter, fear of love, fear of waking up, fear of swollen membrane). Initially written by Gordon as a kind of stream of con-sciousness and often appearing in opposing pairs, the fears are listed in white text running around the full length of the walls of a darkened room painted deep blue, illuminated only by three bare bulbs. Each of these is suspended at a different height, roughly equivalent to that of the head, the heart and the genitals: the mind, the body and the sex – the three domains to which all of the fears may relate. The bulbs serve to keep a sense of the origin or location of those fears physically present. The text is without obvious beginning or end, fully encircling the viewer. It is a monument to the psychic self's response to experience and knowledge.

The telephone rings in The Exorcist *and someone wakes up in* Bernadette *as if to answer it – just as if I had structured it that way. And the fact is that I hadn't. But as human beings, we're always wanting to make meaning between one thing and another. I liked the fact that the sound could spill over from one film to another and that you could lose yourself in the confusion of it.*

Between Darkness and Light (after William Blake) presents two films on the same screen, one projected on either side. These are *The Song of Bernadette* (Henry King, 1943) and *The Exorcist* (William Friedkin, 1973), two tales of adolescent girls whose lives are taken over by forces beyond their control. The first is a little-known black and white film telling a famous story of good, the history of St Bernadette, or 'Our Lady of Lourdes'; the second an infamous film about demonic possession. The piece was initially conceived for *Sculpture. Projects in Münster* in 1997, where it was presented in an urban underpass.

In a conversation with Jan Debbaut, Gordon described how the piece and its location, both the specific use of the underpass (fig.61) and the more general context of the city of Münster, came together:

We had already begun to discuss the possibility of showing 5 Year Drive-By *... With this work in mind, we started looking specifically for car park spaces that might be available to use for a big projection, you know – garage spaces, underground, multi-storey spaces and so on. It turned out to be one of the most miserable days imaginable.*
It was absolutely pissing down in Münster. And I mean for twenty-four hours. The only shelter that we got while walking around was to go into these car parks, which were, of course, totally choked with exhaust fumes and pollution and so it became clear pretty quickly that we weren't going to find an appropriate place for that film project in Münster. I was quite depressed about the situation and then, by chance we were driving along a road and Kasper König said: 'Oh, maybe you'd like to see the underground space that Joseph Beuys tried to work in. That might be interesting.'
So we went into this space, which is a pedestrian underpass, and as soon as I went in I realised ... it was stinking, with urine and shit in the corners, litter everywhere and graffiti all over the walls, and god knows what else all over the place ... So, I thought 'Yes! This is probably the worst possible space for any artwork that you could have in

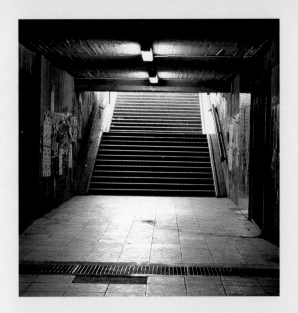

View of the underpass used for *Between Darkness and Light (after William Blake),* 'Sculpture.Projects in Münster' 1997 [61]

this city – no-one else will want it so it's perfect for me.' And I liked the fact that it already had a history with the Münster Sculpture Project . . .

At last I forced myself to stop thinking about Beuys and start thinking about what the space could mean in metaphorical terms. If it wasn't an underpass then what else could it be? And I imagined that it might be seen as a conduit between one part of the city and another. So then it could be a conduit between one representation of the city and another – and the underpass literally directs you from the castle to the university and the church.

I was interested in that kind of contradiction in urban architecture, that places built for safety can become the most dangerous sites in the city. A paradox between the function and the reality. But at the same time I had been evolving these ideas of what the underpass could be because I was reading a little about the history of Münster. And when you're living in Münster, or spending some time there, you really don't need to read about the history so much because it's still alive . . . I've never seen so many nuns and priests, anywhere, in my experience. This was the most intense concentration of religious power, probably, outside of the Vatican. Or so it seemed to me. Even the hotels had crucifixes on the walls above your bed. My God! I tried to take my crucifix off the wall while I was living in one hotel – but it was impossible. It had been made with rounded edges so that you couldn't even get a grip on the thing in order to try and prise it off the wall!

Anyway, the fact that the whole area is so Catholic meant that I could probably work with certain religious mythologies and beliefs . . . At least in this situation it seemed like people would be able to understand what I might try to do. Now, bear in mind my idea of the underpass as an in-between place, or state of mind, and then think about what this would mean under some kind of religious ideology – at least a Catholic belief system.

I started to think about the underpass as some sort of purgatory. It's neither in the city nor out of it. It is neither in heaven nor in hell. I began to think that it might be

BETWEEN DARKNESS AND LIGHT
(AFTER WILLIAM BLAKE) 1997
[62, opposite and 63, overleaf]
Video installation
Dimensions variable
Installation view: 'Cinéma Cinéma', Stedelijk Van
Abbemuseum, Eindhoven, 1999
Stedelijk Van Abbemuseum, Eindhoven; Museum
of Contemporary Art, Los Angeles
Courtesy of the artist and Lisson Gallery, London

*interesting to try and stop people passing through it as quickly as they might have done
normally. If I could find a way to make people hang around there for some time, then it
would become a space for thinking, reflecting and waiting to see what might happen next.*

It was like a perfect model of purgatory.

The formal partition of the space by means of a projection screen served to
heighten the understanding of the underpass as a space of intermediacy, a place
in which two extremes converged. However, the films projected onto the surface
are visible from both sides, making it almost impossible to discern which film
originates from which side. The experience is more one of confusion than
distinction, of synthesis rather than separation. Gordon's account of what
interested him in combining the two films in this way is, like the bedroom origins
of 24 Hour Psycho, rooted in the day-to-day:

*I think I was just reflecting on how one synthesises and then separates details from one
moment to the next. I was just lying in bed one night thinking about what had
happened during the day and trying to make some sense of all the things that I'd heard,
all the things that I'd seen, all the people that I'd spoken to in that day. I realised that
usually when you're on the telephone having a conversation, or an argument, you're
also typing on your computer or watching TV and listening to some music, and trying
to eat and drink, and think about what to do later that evening, or tomorrow, or next
week, and so on. I was fascinated by how this mess of information and experience can
be synthesised into something else... Only allowing two things to mix together would
maybe get me to the point where you can make sense of even the most chaotic images
or pictures that formally and aesthetically are battling with each other. And if you can
make sense of it, then it becomes a beautiful metaphor for what is happening in the
films themselves. While one film is representing good and one film is representing evil,
the fact is that they can coexist quite easily together – on a physical and conceptual level.*

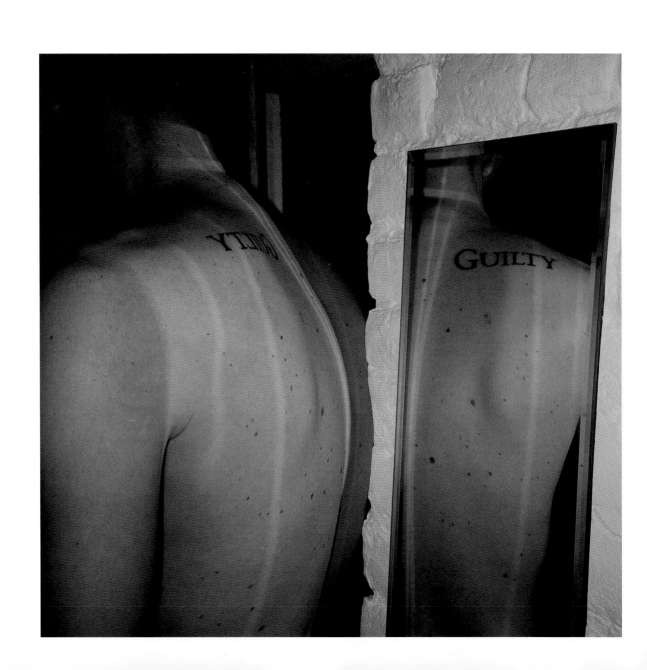

5

Consolidating several emergent thematic concerns in Gordon's work, such as the ways in which good and evil are defined and perceived, *Between Darkness and Light* also made use of his familiar formal and strategic approaches. The bodily involvement of the viewer, achieved by means of contingency with and proximity to the screen, the fusion of conflicting perspectives, physically and psychologically, and a strong sense of physical disorientation are among the most prominent characteristics of this piece as well as several that preceded and followed it. It also extends the exploration of splitting and doubling in his work: the screen as two-dimensional object with two equally functional sides, literally two-faced; the two alternative approaches to the space and each route's relationship to the city, with church in one direction and the state in the other. The knowing choice of this marginal space, both literally and metaphorically underground, achieves something of the same effect as the co-option of illicit material in the *Bootleg* works (figs.43–5 and 47) and others. For the tunnel, despite its intended functionality as controlled safe passage, has, like so many of its ilk, become the natural site for transgressive behaviour, whether simply unacceptable or actually illegal. A hidden space, concealed from the face of the city, the marginality of the structure itself and the social position of those who would normally spend time there is a substantial component of the work's impact: will encouraging the viewer to linger in such a space expose them to undesirable influence? Will he/she succumb to the anti-social forces that tend to prevail? Does spending time in such a space lead to a certain type of behaviour? Can environment alone corrupt or contaminate?

There's no doubt that many people who encountered the work in Münster felt uneasy with it, struggling both to figure out exactly what was going on with the images before them – where they were coming from, what they were – and to linger in a space that would normally be rushed through, if entered at all. The threat posed by such spaces is that something undesirable will penetrate your world, that you will experience someone or something unpleasant, disturbing, even violent. It's a familiar scenario for any city-dweller, who knows the safe routes and the no-go areas. Although the piece can and does stand alone in a more neutral gallery space, *Between Darkness and Light* is particularly significant as the first work Gordon had realised in several years to engage specifically with this kind of public or at least 'non-art' site. As such it is one of a small number of works made in the late 1990s that relates back to earlier work such as *Meaning and Location* (fig.2), exhibiting the same sensitivity to site and eagerness to co-operate with context.

I was well aware that this was a public space and that it would have problems and so on but I tried to treat it pretty much the same way that I would treat a gallery space, or a museum space … It's public but it's hidden – so it can be private in a way. So the films aren't being seen in the cinema and they are not being seen purely publicly either because you've got to make a decision to go down some steps and enter into the underpass. It's not so public after all.

As Gordon says, 'It's not "in your face" that interests me, it's "in your head"'. In other words, it's not the mass exposure potentially available from the public realm, but the ability to use the different psychic engagement we have with it, compared to the gallery or museum. The fluency of integration between idea and space, between meaning and location, that characterises *Between Darkness and Light* is also at play in his only permanent public work to date, *Empire* 1998, and in his approach to a major exhibition at the Kunsthaus Bregenz in 2002. The understanding and subsequent

THREE INCHES (BLACK) 1997 [65]
One of series of eleven
C-print
80.5 x 105 (31 ½ x 41 ³⁄₈)
Yvon Lambert, Paris

exploitation of architectural qualities is common in all.

The Song of Bernadette and *The Exorcist* share a focus on the embodiment of the two diverse inner states they depict, continuing Gordon's interest in the bodily manifestation of the psyche. His concern for the inscription of memory on the body in *Trigger Finger* (fig.28) and other works also emerges in his recurrent use of the tattoo. A typically simple but powerful example of this is the work *Tattoo (for reflection)* (fig.64) made in 1997, whereby a collaborator agreed to have the word 'GUILTY' tattooed in black on his shoulder. The potency of the work lies in the fact that the word is written in reverse and is thus only properly legible when viewed in a mirror. The work, a colour photograph of a bare shoulder and its reflection in a mirror, makes explicit use of the reflecting device implied in so many of Gordon's video works. In this instance the alienation and tension between self and other is powerfully felt – the reflected self almost seeming the more true as the lettering is 'correct' in this version. Which is the real person? Can we really tell from the photograph? Is it the artist? It is hard to be sure as the subject's face is hidden from view. If not, what is the relationship between artist and subject? With whom does the guilt lie? The imaginative consequence of the image is the thought that this individual will be reminded of all or any acts about which he feels remorse whenever he catches sight of his back in a mirror. Just as the *Instructions* rendered as phone calls made use of a ploy recurrent in gangster movies, *Tattoo (for reflection)* subtly and indirectly references familiar filmic strategies. It brings to mind scenes of self-loathing in movies: the angry, disillusioned, guilty individual who cannot bear to look him or herself in the eye, the smashed mirror that invariably results. The reflected self in these scenes seems to insist on the socially subjugated, hidden, unacceptable face, with the breaking of the glass as the symbol of self-hatred and guilt.

A further tattoo work of the same year returned to a focus on the hand, while extending the sense of alienation conjured by the use of the mirror in *Tattoo (for reflection)*. *Three Inches (Black)* (figs.65–6) is the title of a group of eleven colour photographs that depict a man's hands, on which the left index finger is a deep inky black, the result of a tattoo made to a depth of three inches from the tip. The specific measurement is derived from a remembered story about a police campaign in Glasgow many years ago, whereby sharp items of three inches in length or more could be confiscated as potentially deadly weapons, since this was sufficient length to reach a vital organ if it pierced the surface of a human body. It would be long enough to reach the heart.

It is possible to find an element of metaphoric and poetic tenderness in this notion visually, but the intense estrangement felt when looking at the blackened finger tends more to the violent, the aggressive. It lies like an object apart from the rest of the hands, whether at rest or tapping the table as if to emphasise a point. Just like *Trigger Finger* and the *Bootleg* group of works, in which the performers' hands touch their own bodies or reach out to their adoring fans, whose own hands wave as if compelled by another force, this bodily detail becomes a symbol of the psychic inner being that controls it. The hand is a frequent subject in Gordon's works, as expressive and communicative of emotion and identity as the face. In 1998 he made a group of three video works, again using his own hands. *Left Dead* and *Dead Right* (fig.67) both show him applying a tourniquet to one wrist, cutting the hand off from the life support of the rest of the body. *Blue* (fig.68) shows two hands in close-up, at first at rest but then in an increasingly

THREE INCHES (BLACK)
(detail of installation) 1997 [66]
Eleven colour photographs
Installation view: 'what have I done',
Hayward Gallery, London 2002
Yvon Lambert, Paris

DEAD RIGHT 1998 [67]
Video installation
Dimensions variable
Collection Eileen and Michael
Cohen, New York
Courtesy of the artist and Lisson
Gallery, London

BLUE 1998 [68]
Video installation
Dimensions variable
Collection Eileen and Michael
Cohen, New York
Courtesy of the artist and Lisson
Gallery, London

animated interplay that has undeniably sexual overtones, as the thumb of one hand seeks out the soft fleshy crevice of the other. The pieces all reference a kind of idle fidgeting, the sort of thing we might do when mentally preoccupied. But they go beyond this: the behaviour becomes decidedly compulsive and determined. They recall the old saying that 'the devil finds work for idle hands'.

Gordon's own hand also features in a rare object made in 1999, in which a severed finger recalls the blackened finger of *Three Inches*. The work is a cast of the artist's own hand, from which the ring finger has broken off. Entitled *Fragile hands collapse under pressure* (fig.69), it returns us to those themes of emotional breakdown encountered in the earlier *Letters*, even though the pressure here was physical. The insistent tone that characterises many of the *Letters* and *Instructions* (figs.11–13) is also revisited in an installation entitled *What you want me to say* 1998 (fig.70). A work that again sets up a relationship between object and subject, speaker and listener, this piece relies on an inter-relationship of form and content similar to *30 Seconds Text* (fig.50). It comprises a dozen black audio speakers dotted across the floor, connected by means of long, heavy black cables that snake their way back to the origin of the sound: a simple record player with a record that continually repeats the phrase 'I love you', followed by a click, as if the needle were stuck. It is typical of Gordon's corruption of the familiar that in this installation those three well-worn little words rapidly become troubling. This is due to a number of factors: the physical excess of the technical mechanism for playback, the continual repetition and, of course, the title, which introduces some doubt as to intent and sincerity. It shares something of the disjuncture of those earlier text works describing various states of

amnesia (*I remember nothing* [fig.19] and so on) in as much as the bare minimum of three words insist on meaning something powerful, and it's a something everyone wants to hear.

The story behind this piece and the origin of its title lie again in film, the screen adaptation of Graham Greene's *Brighton Rock* (John Boulting, 1947), set in the violent criminal underworld of Brighton. The anti-hero of the story, Pinkie, convinces a sweet, naïve young woman, Rose, to marry him. He does this purely so that she can't testify against him if his crimes come to trial, as she is a potential witness to a murder he has committed. Gordon summarises the plot:

She loves him and he despises her. He's a really nasty piece of work but she doesn't see this because she loves him. After they get married, they're walking along Brighton beach and they see one of these old 1950s booths. It looks like a telephone booth but it's where people can record whatever they want, and she says 'Oh, go and make me a record of your voice'. So he goes into the booth and she's standing outside looking in and she can't hear what he's saying. And he's a bastard and he says: 'You asked me to make a record of my voice. What you want me to say is I love you, but here's the truth, I hate you . . . ' And you and me – the audience – are privy to the information, but she doesn't know. So the tension of the film is all about what's happening to the record. At the end of the film, Pinkie dies and she's still in love with him, and she ends up in a convent. In the last scene of the film, she's talking to the Mother Superior about the beauty of love, redemption, and the possibility of life without love. And the Mother Superior says 'You know there's still hope for him after death if he really loved you', and the girl says 'Mother, I know he did. I've got proof. I've got his voice'. And you're thinking 'NO, don't play it!' and she plays it and you hear him saying: 'You wanted me to make a record of my voice. You want me to say "I love you" . . . (click) . . . I love you

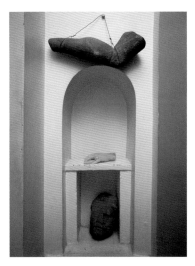

FRAGILE HANDS COLLAPSE UNDER
PRESSURE 1999 [69]
Wax
25.4 x 12.7 x 7.6 (10 x 5 x 3)
Installation view: 'Contemporary
Artists at Sir John Soane's Museum',
Sir John Soane's Museum,
London 1999
Collection of the artist
Courtesy Yvon Lambert, Paris

WHAT YOU WANT ME TO SAY
1998 [70]
Audio installation
Dimensions variable
Installation view: Centro Cultural
de Belém, Lisbon 1999
Migros Museum für
Gegenwartskunst, Zurich

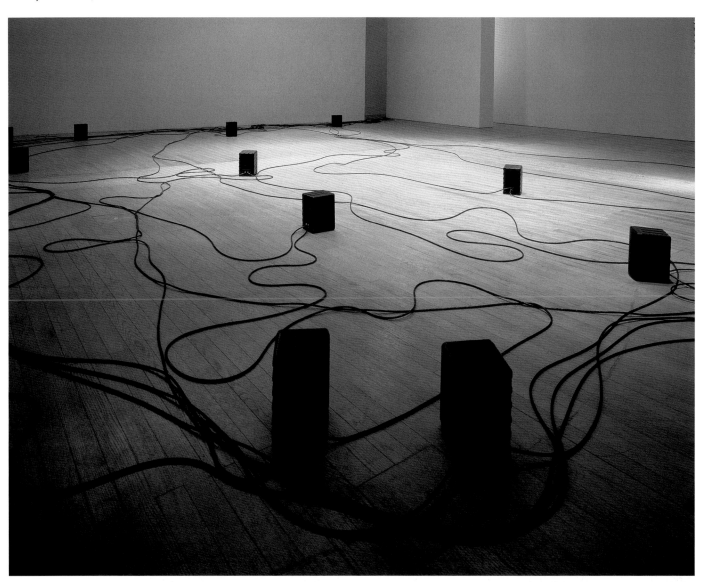

Andy Warhol
RORSCHACH 1984 [71]
Synthetic polymer paint on canvas
58.4 x 53.3 (23 x 21)
Andy Warhol Museum, Pittsburgh,
Pennsylvania

(click) I love you (click)', and the needle's stuck, so she never finds out.

The film itself is an almost perfect description of good and bad, of two young people prone to different forces, one to love and the other to hate. Its ultimate horror lies in the ramifications of truth, trust and belief, which is what gives Gordon's installation its impact. The story may of course be completely unknown to the viewer, but the doubt cast by the title alone sets up the necessary relationship. 'The artist wants people to love him or her and in a way, the visitor to an exhibition also wants to love someone, whether in a metaphysical way or more literally . . . Everyone wants someone to say "I love you" and on the one hand that's what I'm doing,' says Gordon. While in many ways this work recalls works by Bruce Nauman and others, which focus on the dependent relationship between artist and viewer, they solicit contrasting emotions. Nauman's *Get out of my mind, get out of this room* 1968, for example, relies on hostility rather than tenderness, though the deceit implicit in Gordon's work may of course be equally cruel. The antagonistic injunction of Nauman's piece is inverted to become ultimately perverse in Gordon's.

Despite its basic structure, *What you want me to say* is also distinguished from early Conceptual art by its viscerality. As Gordon says, 'you can be conceptual and visceral at the same time', echoing the exchange between mind and body that is a feature in sustaining many other works, not least *30 Seconds Text*. The surfeit of cable is distinctly visceral, while the highly evident equipment prioritises mechanics over meaning to further undermine the transmitted message. The possibility that meaning will be lost en route increases, highlighting the subjectivity of interpretation and the unknown and unknowable intent of the speaker. The formal configuration stresses the distance between speaker and listener, foreclosing any potential intimacy set up by the initially endearing statement of love. The voice is, after all, obviously a recording, a further manifestation of Gordon's exploration of the evasiveness of truth and the slipperiness of meaning.

The use of repetition in this piece recalls learning by rote – the inculcation of information through re-iteration, a method known to convey the information but not necessarily an understanding of all it signifies. It also relates to the looping, endless present of many other works and to the well-known phenomenon that even the most familiar words can seem strange when repeated. It is fundamentally concerned with desire: how it can skew interpretation, how it extends into obsession and the insanity that emerges from insistence.

Establishing meaningful access to the inner workings of the mind has been the quest of psychiatry since the discipline was established. As we have seen, Laing's work in social psychology in the 1960s sought to access those workings when distorted through schizophrenia. Another tool, in widespread use in the 1940s and 1950s, is the famous Rorschach test, which bases interpretation on what subjects could see in a series of symmetrical inkblots, first published by Swiss psychologist Hermann Rorschach in 1921. As a psychometric instrument it was seized upon and used extensively, despite the lack of a fully formulated system for interpretation (Rorschach died before it could be completed). It relies chiefly on vision and assumes the operation of the eye to be objective, that the mechanism feeds the same information to everyone and that any differences in what is 'seen' are engendered by the operation of the mind in response to the visual information supplied to it. So when two people respond differently to the same inkblot, seeing distinct forms or references in it, the differences are

OFF-SCREEN 1998 [72]
Video installation
271 x 373 (106 ½ x 146 ⁷/₉)
Installation view: Centro Cultural
de Belém, Lisbon 1999
Courtesy Lisson Gallery, London

LEFT IS RIGHT AND RIGHT IS WRONG
AND LEFT IS WRONG AND RIGHT IS
RIGHT 1999 [73]
Video installation
Dimensions variable
Installation view: 'Double Vision
(with Stan Douglas)', Dia Center
for the Arts, New York 1999
Ydessa Hendeles, Toronto; Hauser
and Wirth Collection, Zurich
Courtesy of the artist and Dia
Center for the Arts, New York

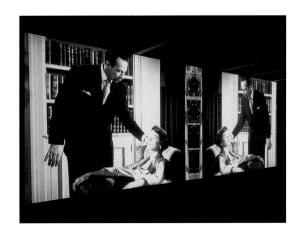

construed as indicative of personality traits, revealing hidden fears, anxieties or desires.

The test lends its name to a series of paintings by Andy Warhol made in 1984 (fig.71) and is also a visual reference for a major projection work produced in 1999 by Gordon for the Dia Center in New York. *Left is right and right is wrong and left is wrong and right is right* 1999 (figs.73–4) employs Gordon's most emphatically structural approach to film, separating even- from odd-numbered frames of a black and white film made in 1949. This produces two distinct films, which are then projected side-by-side, one inverted, in a near mirror image of the other, so that what appears across the whole projection area is a symmetrical, Rorschach-like image. Despite appearances, the images either side of the divide are not truly identical, separated as they are by a split second in time. Not insignificantly, the inverted images are on the left-hand side, the sinister half associated with the devil. Together the two halves form a new whole, in which a pleasingly hypnotic pattern is to be found if the viewer does not succumb to the dangers of the stroboscopic effect, of which viewers are warned at the entrance, and which make this the most likely of all Gordon's works to actually induce the kind of altered states that have appeared elsewhere.

The film used in this work is Otto Preminger's *Whirlpool* (1949), a classic noir thriller, whose promotional poster read 'Can a man make a woman do things she doesn't want to?' With a cast of characters that includes a kleptomaniac, a psychiatrist and a hypnotist, it is a film clearly concerned with the realm of the psyche. Its narrative charts various attempts to exert power over others, complex notions of moral responsibility, guilt and a search for the truth that is common to both psychoanalysis and crime detection. Both processes share a need to bring the past to light in

LEFT IS RIGHT AND RIGHT IS WRONG
AND LEFT IS WRONG AND RIGHT IS
RIGHT 1999 [74]
Video installation
Dimensions variable
Installation view: 'Double Vision
(with Stan Douglas)', Dia Center
for the Arts, New York 1999
Courtesy of the artist and Dia
Center for the Arts, New York

order to understand the present, a present that in *Whirlpool* is hugely uncertain due to the duplicitous nature of more than one of the characters. Thematically, the film shares much with many of Gordon's previous works, not least in its observation of manipulation and control.

The inversion of both imagery and title is parallel to that of *Untitled Text* (fig.53), where the central point, the middle ground, becomes the real focal point, the platform for exploring what is perceivable by the mind's eye. This charged central territory is sought by so many of Gordon's works that refuse the single viewpoint and the certainty of the extremes that lie to either side. His apparent desire to encourage his viewer to occupy this ground, to acknowledge it as a physically in-between state, is an insistent force in *Off-screen* 1998 (fig.72), another projection work and one of several to feature in a major exhibition of Gordon's work presented at the Centro Cultural de Belém, Lisbon in 1999. *Off-screen* brings the viewer to occupy an intermediate space, only in this instance in a corporeal sense. The work comprises a curtain made of projection material, onto which a video recording of a curtain is projected on one side. Both real and recorded curtain move slightly, exposing their separation. Installed at the very centre of the exhibition, the viewer has to pass through it in order to reach the works that lie beyond. Approaching the curtain to part it and walk through inevitably blocks the projection, the viewer appearing on screen/curtain in silhouette. As an architectural exhibition device it reinforces Gordon's view that 'people should feel that they have physically gone into the work'. It implies a threshold, which the viewer has to make a conscious decision to cross. With this implication and active participation of the viewer, *Off-screen* develops the spatial configuration of those earlier video projections such as *10ms⁻¹* (fig.29).

Original poster design by Saul Bass
for Alfred Hitchcock's film *Vertigo*,
1958 [75]

EMPIRE 1998 [76]
Neon sign, mirror
Collection Merchant City Civic
Society, Glasgow

The coincidence of criminal detective work and psychoanalysis is a common thread in the thriller genre employed in *Left is right and right is wrong and left is wrong and right is right*, and not least in the films of Hitchcock. The main character in *Vertigo* (1958) (fig.75) is Scotty Fersuson (played by James Stewart), a detective forced to retire due to acrophobia that had contributed to his inability to save his partner from death during their pursuit of a criminal. The film has given rise to two major works by Gordon, including a major permanent public piece for his native Glasgow. *Empire* 1998 (fig.76) comprises a neon street sign, replicating one that appears in the film. It is the name of the hotel in which the guilt-ridden Scotty comes across Judy Barton, the second incarnation of the duplicitous female character played by Kim Novak.

For this commission, Gordon chose another marginal site, a narrow lane that serves as a conduit between a busy shopping street and the increasingly gentrified and residential Merchant City. It is a pedestrian route, occupied by a couple of bars, a sauna/massage parlour and a sandwich shop, one of those marginal parts of the city with an entirely divided character, functional by day and more than a little seedy by night. One of the bars was for many years the favoured haunt of the post-opening crowd from the nearby artist-run Transmission Gallery. On the office block opposite the bars, Gordon installed a two-sided vertical sign with bold green letters reversed, legible in the mirror applied to the section of building on which it is mounted. It reads 'EMPIRE', suggestive but non-specific. For the non-film buff, it could be construed as reference to the British Empire or the infamous Glasgow Empire theatre that used to stand nearby, or even as a territorial marker of the loose association that is Transmission. But it surely also evokes the presence of a parallel world through the mirror, an underground empire behind/beneath the main thoroughfares and sanctioned routes in any city. Vaguely old-fashioned in colour and form, its simple, unfussy lettering recalls a time when the neon alone would have been enough to draw attention on a city street. Nowadays, something more is needed and Gordon's sign supplies it via deliberately 'broken' letters, a permanently flickering light in the letter 'P' on one side and 'I' on the other.

Throughout 1998, Gordon was also working on the second piece to draw on *Vertigo*, his first major original film work, aptly titled *Feature Film* (pp.94–7).

Between 1993 and 1997–8 most of my video and film work was silent and this unbearable silence was what got me interested in looking specifically at the musical or audio component that had already been used in film. One development of that was to make a work called Feature Film *where really I made a film but used an existing piece of music. . . . the soundtrack from Hitchcock's* Vertigo, *written by Bernard Herrmann. We borrowed the music and had a conductor re-make the score.*

Gordon's film focuses almost exclusively on conductor James Conlon, *chef d'orchestre* of the Paris Opera, as he leads his musicians through the score. The camera focuses on his hands, occasionally his brow and eyes, which mirror the intensity or calm of the music. *Vertigo* has a particularly dramatic score, typical of Herrmann's distinctive work for film, which also featured on *North by Northwest*, *The Birds* and *Psycho*. In *Vertigo* it is also concerned with the themes of memory and psychoses that interest Gordon. There are frequent refrains, recurrent motifs running through the score, some associated with individuals, some with emotions, others with particular incidents, a standard cinematic technique of which Hermann's *Vertigo* score is the epitome. The film itself is also characterised by exceptionally sparse dialogue and extended periods with no speech and indeed some with no sound at all. At one point, the protagonist, John 'Scotty' Fergusson (played by James Stewart), is confined to hospital, struck dumb by the second traumatic incident we see him endure, unable or unwilling to speak due to what his doctor describes as 'acute melancholia together with a guilt complex'.

Vertigo is based on a French novel by Pierre Boileau and Thomas Narcejac entitled *D'Entre les Morts* (translated as 'From Among the Dead', which was used as an early working title for Hitchcock's film). The trailer features a mock dictionary entry for the word 'vertigo': 'a feeling of dizziness . . . a swimming in the head . . . figuratively a state in which all things seem to be engulfed in a whirlpool of terror'. It is a fitting analogy, for this film's story seems endlessly to spiral in on itself, one of its attractions for Gordon.

The immediacy of the plot was gratifying, but the absence of any resolve all the way through was beautiful. Then at the end you are still denied the moment of closure. 'Things can't possibly end this way,' we think. For me that made it absolutely not

Eija-Liisa Ahtila
CONSOLATION SERVICE 1999 [77]
35mm film and DVD installation
for 2 projections with sound
(24 minutes)
Courtesy Anthony Reynolds
Gallery, London

Hollywood cinema, and it even went beyond the best of the art-house stuff. Constant denial. How can you do that with James Stewart and Kim Novak? It's just two fingers in the face of everybody – that's what I love about it.

Unusually, there are two versions of the work. One is a 35mm film for cinema-type projection, which is 74 minutes in length – the duration of the score. The other is a video installation, comprising a large-scale projection of Gordon's film and a smaller projection of the original film, played without sound at an oblique angle elsewhere in the space. This version is also exactly the same length as the original film, with the silences in the score rendered in Gordon's film as dark voids. At these points, the viewer is invariably drawn to the Hitchcock film, playing silently elsewhere in the space. Using the same material in different ways may make it awkward for those seeking a definitive view of 'the work' – and this refusal fits perfectly with the concerns manifest in Gordon's broader practice – but it shows a truly engaged understanding of the medium and its possibilities. When he has been asked which is his preferred or definitive version, his response has been: *surely I worked fucking hard enough to make this thing live more than one life. Surely it shows that a desire for various edits of work means there is no need to be definitive.* It is an approach shared by other artists, such as Eija-Liisa Ahtila, whose *Consolation Service* 1999 (fig.77) was first shown the same year and exists both as a 35mm film for cinema projection and a two-screen DVD installation. Both *Consolation Service* and *Feature Film* seek out the possibilities of and differences between each format, the locales they necessitate and what they offer to and demand of the audience. Both show an astute awareness of the physical experience of watching, as much as an understanding of film-making itself.

Demonstrating his characteristic understanding of the way in which the material presence of the work conditions its reception, Gordon describes the first presentation of the *Feature Film* installation in London:

The various surfaces I used for projecting the images were very important in differentiating a reading of the two images. Feature Film *was projected onto a large screen suspended in the room. Conlon's image was visible from both sides and physically dominated the entire space. Even when the projector was switched off,*

FEATURE FILM 1999 [78, below and 79, right]
Video installation
Installation view: Atlantis Gallery, London 1999
Collection Centre Georges Pompidou, Paris;
Kunstmuseum Wolfsburg; Eileen and Michael
Cohen, New York
Courtesy of the artist and Artangel, London

the screen itself had a presence that competed with the existing architecture. Vertigo, *however, was projected onto a nearby wall. The image was much smaller and there was no sound. It felt as though the image could be wiped away, as if, when the projector was switched off, the film had never existed. The original architecture bore no trace of the image that had just been there, seconds before. This made a huge difference in the perception of both images, the difference between a screen and a wall. Beyond the wall was nothing, but with a screen you always have another side. You know there's something on the other side of the screen, whether it's fiction or reality.*

In some sense there's a dilemma about what image you're seeing because the music confuses the issue. While you might be looking at my Feature Film, *you're always conscious that this is music from another film ... there's an image in front of your eyes and an image inside your head. There's maybe some kind of conflict between the two and that conflict is what I would call an interesting game to play.*

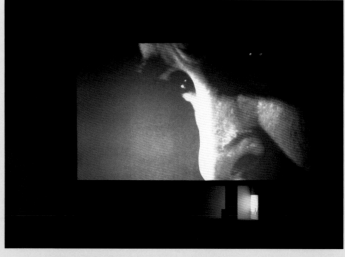

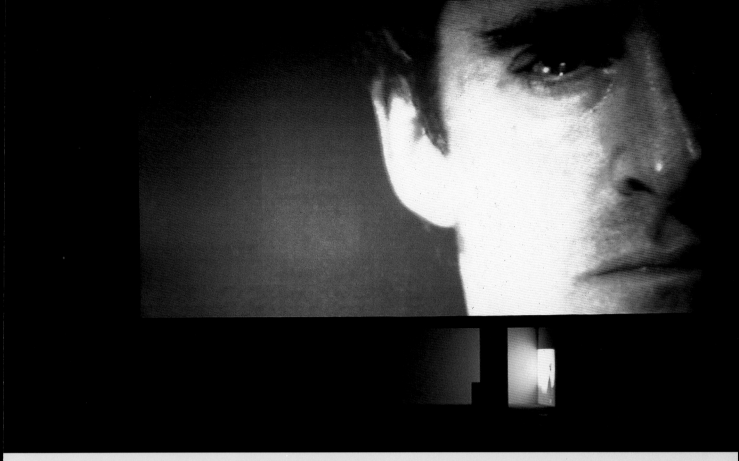

HARMONY 1999 [80]
Video installation
Dimensions variable
Installation view: Moderna Museet,
Stockholm 1999
Courtesy of the artist

6

Feature Film engages the essential mechanics of the film score – the recall and recognition triggered by repeated themes, the heightening of dramatic tension by means of crescendo – pointing to its substantial contribution to the creation of mood and how it affects interpretation. Though music had featured in several earlier works, *Feature Film* was the first piece to bring together Gordon's enduring interest in music and film, looking specifically at the relationship between the two. He took this further with *Harmony* 1999 (fig.80), a project with an academic approach made for the Moderna Museet, Stockholm. Gordon assembled nineteen movies, including *Brief Encounter* (David Lean, 1945), *The Deer Hunter* (Michael Cimino, 1978) and *2001 – A Space Odyssey* (Stanley Kubrick, 1968). Covering diverse eras and genres, times and places, they were related to one another only through the pieces of music used in their soundtracks. The relevant information about the music used in each film was handwritten beside the monitor on which it was shown, with the connections between them indicated by cords drawn out across the space from one monitor to another, indicating, for example, the shared use of Beethoven in *A Clockwork Orange* (Stanley Kubrick, 1971) and *Lorenzo's Oil* (George Miller, 1992). The result was like a bizarre, three-dimensional family tree, representing 'the genealogy of soundtracks', whose branches replicated the mental associations triggered in the receiver's brain. While there was always the tantalising prospect of coincidence, of Rachmaninoff commencing simultaneously in both *Shine* (Scott Hicks, 1996) and *Brief Encounter*, for example, the films, playing continually and concurrently in the space, created an almost unbearable cacophony, rather than harmony, a multiplication and intensification of the audio confusion generated by *Between Darkness and Light* (figs.62–3).

This aural discord was constantly countered, however, by the order sought by the supposed logic of the genealogy. Chaos and order not only co-exist, but stem from the same material. Again exploring and exploiting the effect of the familiar, the process of recognition and the acknowledged power of music to trigger memories, *Harmony* prompted an awareness that what is recalled is not necessarily from one's own experience, but from the fictional world that exists inside our reality.

Had it grown to encompass a broader, extended family, one of the connections *Harmony* might have highlighted is that of the extraordinary contribution made by Bernard Herrmann to some of the most enduring and acclaimed films in cinema history. After a long-standing collaboration with Hitchcock on some of the director's most successful films, Herrmann went on to work with Martin Scorsese. His score for *Taxi Driver* (1976) is his most menacing since *Psycho*, contributing substantially to the film's impact in its depiction of one man's descent into madness. What the film is probably more widely known for, however, is not its score, but its citation in the bizarre story of John Hinckley's assassination attempt on US President Ronald Reagan in 1981. Hinckley had become obsessed with Jodie Foster after having seen her in the role of Iris, the young hooker, in Scorsese's film. After a few years of stalking the actress, Hinckley spectacularly attempted to attract her attention by shooting the President, just as Bickle had sought to impress Betsy (played by Cybill Shepherd in the film) by planning an attack on the presidential candidate for whom she worked. Hinckley was tried and found not guilty by reason of insanity. In its subsequent investigation of the story, a *Newsweek* article quoted Hinckley's own explanation that 'The line dividing life and art can be invisible. After seeing enough

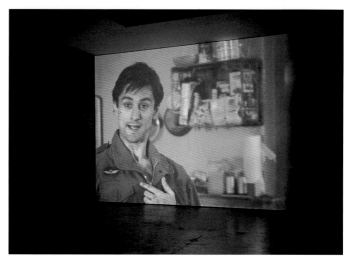

THROUGH A LOOKING GLASS
1999 [81]
Video installation
Dimensions variable
Installation view: Gagosian Gallery
(SoHo), New York 1999
Astrup Fearnley Museet, Oslo
Courtesy of the artist and Gagosian
Gallery, New York

hypnotizing movies and reading enough magical books, a fantasy life develops which can be either harmless or quite dangerous.'

Hinckley's case is one of the most extreme real-life examples of an absolute collapse within one individual of the boundaries between the fictional and the real, between imagination and action, a disintegration that maps the transition from social being to sociopath. The insanity depicted in the film itself is that which gradually engulfs the eponymous taxi driver, Vietnam veteran Travis Bickle, played by Robert de Niro. It is a remarkably compelling depiction of a man whose behaviour degenerates from that of a rather meek, if strange, loner to the positively psychopathic, as he suffers increasingly from paranoia and chronic insomnia. Having built up a personal arsenal to protect himself against the sleaze and violence he sees permeating the city around him, in one of the most memorable and mimicked film scenes ever, Bickle practises his draw against an imagined adversary in the mirror of his miserable apartment: 'You talkin' to me?'

This is the scene that Gordon uses in *through a looking glass* 1999 (figs.81 and 101). Extracting the crucial seventy seconds, he duplicates the footage and projects the two pieces of film onto facing walls in a darkened room, with one sequence flipped left-to-right to mirror the other. They are not synchronised, one running slightly after the other, the differential increasing with each progressive screening, so that what at first appears to be a small glitch develops into a time lapse that allows Bickle to be in dialogue with his reflection, with the viewer placed between the two, caught in the crossfire. Gordon describes the formal structure of the piece in relation to the mirror into which Bickle/De Niro is performing and which is referenced in the title (De Niro did not actually play to

camera, but into a mirror, from which the scene was filmed). He sees it as 'amplifying the gap' between the front and back of the mirror, imagining the way in which light travels through space, whereby it will reach the front surface of a mirror before being absorbed by the darkened back, and then reflected outwards. *through a looking glass* takes this infinitesimal, split-second gap and stretches it to echo the widening schism in Bickle's personality. It is one of many examples of the 'suspended instant' in Gordon's work, others including *Bootleg (Stoned)* (fig.47), *Confessions of a Justified Sinner* (fig.54) and *Remote Viewing* (fig.36), each of which takes a small moment from a wider sequence and opens it up to render it strange, heightening the viewer's sense of distance from what is depicted. Denuded of the sur-rounding narrative, of the explanation that would draw the viewer into the moment, only the crux remains.

Through a looking glass also features a further intertwining of film and literature, by summoning Lewis Carroll's sequel to *Alice in Wonderland* through its title. Another personality split is evoked by implication: that of the book's author, for 'Lewis Carroll' was only one aspect of its creator – a pen-name and associated public persona assumed by the real Charles Dodgson. Published in 1872, *Through the Looking-Glass* is the very depiction of inversion, a world seen the wrong way round, both in space and time. The inspiration for the story is, like *Alice in Wonderland*, a young girl called Alice Liddell. He had asked her to hold an orange in her right hand and then to look at herself in a mirror and tell him in which hand she was holding it. She answered that it was in her left. When he asked her to explain how this could be possible, she is said to have replied, 'Supposing I was on the other side of the glass, wouldn't the orange still be in my right hand?'

DÉJÀ VU 2000 [82]
Video installation
Dimensions variable
Installation view: 'black spot',
Tate Liverpool 2000
Musée des Beaux Arts, Brussels

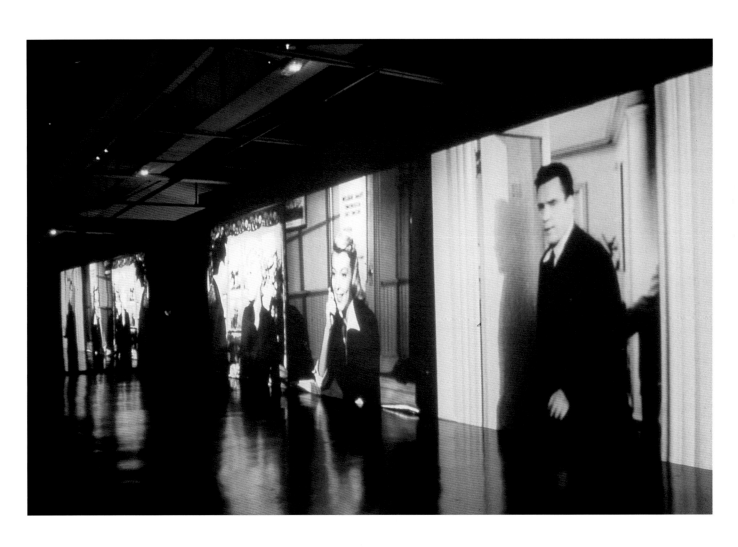

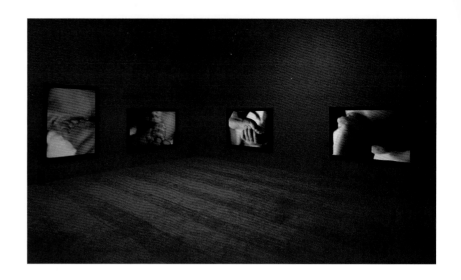

CROQUE-MORT 2000 [83]
C-print
94.6 x 137.2 (37 ¼ x 54)
Installation view: Gagosian Gallery,
New York 2000
Arts Council Collection
Courtesy Gagosian Gallery,
New York

Whereas *through a looking glass* relies on techniques of doubling and mirroring, of separation, opposition and inversion, *Déjà vu* 2000 (fig.82) depends rather on multiplication and fusion. This large video installation comprises of three contiguous projections with sound, each of the film *D.O.A.* (Rudolph Maté, 1950). The three are identical in every respect, but are shown at different speeds, with one running slightly slower and the other slightly faster than standard speed: at 23, 24 and 25 frames per second respectively. What commences simultaneously gradually slips into three distinct time frames, a confusion compounded by the difficulty of marrying each soundtrack to the correct image. A less well-known film than *Taxi Driver* or *Vertigo*, *D.O.A.* is none the less familiar in genre: it is an archetypal film noir with a memorable opening scene in which the protagonist, a character named Frank Bigelow, stumbles into a police station to report a murder – his own. He has been poisoned and has a week to live, the time in which he hopes to find his murderer.

The fantastic intrigue set up by this initial incident shares with many of Gordon's works a concern for matters of life and death, as well as a questioning of the relative merits of knowledge over ignorance. A stark choice between 'Life or death' was proposed in an early letter, *Letter Number 6* 1992, while a more recent group of seven large-scale colour photographs set up an uneasy pairing of those two extreme, universal moments. The images are close-ups of new life, a baby biting her toes, while the title, *croque-mort* 2000 (fig.83), is the old French term for undertaker. The phrase, which translates literally as 'crunch-dead', derived from the medieval practice, in the absence of any more reliable scientific methods, of biting the toes of the suspected dead to ensure that life had indeed ceased. Conversely, Gordon's images depict what may be the first signs of the

intuitive search for a sense of embodiment, the body turning on itself to verify its existence, to achieve sure physical awareness of real presence in time and space, the 'pinch-me' reality check. The narrative of *D.O.A.* might also be seen to lie behind a subsequent pair of letters, *Letters 18a and b* 2000, which read respectively 'It's better to know' and 'It's better not to know'.

In yet another astute coalescence of form and content, *Déjà vu*'s thematic connection to *D.O.A.* is amplified by its structural presentation. Its form makes explicit a past, present and future, of which only the present is unknown to Bigelow, for he knows that he was poisoned and that he *will* die. The content of Maté's film and the form of Gordon's work together make for the kind of schizoid experience first suggested by *24 Hour Psycho* (fig.1), with its insistence on a relentless present in the face of knowledge of both past and future. Now, however, the work relies not on familiarity or prior knowledge, but on immediate, primary apprehension. Both *Déjà vu* and *through a looking glass* exemplify the extent to which Gordon's treatment of ready-made material has become more layered and specific, without losing any of the striking simplicity of those earlier single-screen works. The recognition that is triggered in encountering *Déjà vu*, the sense of 'previously seen' that lends the work its title, is a strange, uncertain and unsettling recognition, as one struggles to establish the relationship is between the three images and soundtracks. Did I just see that same scene in one of the other films? Which one? Which is running faster? The repeated imagery frustrates the desire for sequential logical narrative, suggesting more of a traumatic rupture that cannot be escaped.

Déjà vu featured prominently in two major exhibitions realised in 2000. The first, at the Musée d'Art Moderne de la Ville de Paris, emphasised those

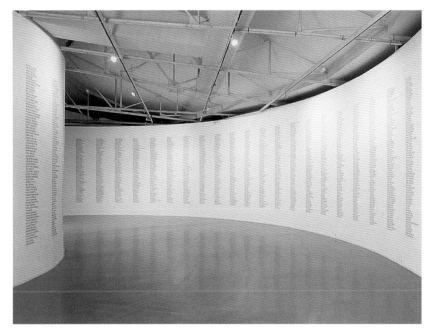

concepts of segregation, division and selection accentuated by its title, 'Sheep and Goats', one of many Biblical references in Gordon's practice. In the Book of Matthew (Matt.25:31–46), Christ's division of the nations is foreseen 'as a shepherd divideth his sheep from the goats … He shall set the sheep on his right hand, but the goats on the left.' The sheep are 'blessed' believers, followers and co-operators invited to heaven, while the goats are 'cursed' non-believers, independent and resistant, consigned to hell. This theme of segregation, and the identification of a chosen elite, is at the very core of James Hogg's text, which had, since lending its title to *Confessions of a Justified Sinner* (fig.54), become of increasing fascination to Gordon, coinciding as it does both thematically and structurally with many of his own concerns. It features the tale of a pious and embittered young man, Robert Wringhim, who is persuaded to carry out evil deeds, including the murder of his own brother, by a mysterious demonic double, Gil-Martin, who uses the Bible, or an extreme Calvinist interpretation of it, as his justification. He exploits the concept of predestination, that once an individual is chosen as 'good', no evil deed can consign the righteous, the truly justified, to hell. The story is told in two separate narratives, from two distinct perspectives, one of which is Wringhim's own. The remarkable and long-neglected book was later to form the basis of a trio of new works made for the Kunsthaus Bregenz in 2002.

The exhibition in Paris physically incorporated the division implied by its title, offering two routes, left and right, for the visitor to choose between. It included, among other works, two versions of *Off-screen* (fig.72), one of the first instances of Gordon duplicating his own work. Nothing could be stumbled upon unwittingly; routes had to be selected, thresholds

DON'T THINK ABOUT IT 2001 [85]
Video installation
Courtesy of the artist and Lisson
Gallery, London

NEVER, NEVER 2000 [86]
C-Print
61 x 76 (24 x 30)
Courtesy of the artist and Lisson
Gallery, London

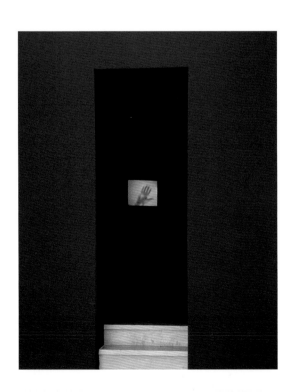

knowingly breached, though ultimately the two paths were re-united in the uniquely arcing space of the museum. Extending the suggestion of selection and segregation, the exhibition also included *List of Names* (fig.84), Gordon's own chosen ones. *Sheep and Goats* highlighted the way in which Gordon's works create a parallel between the coexistence and interdependence of good and evil, right and wrong, light and dark and the temporal conjunction of distinct moments that characterises *List of Names*, *Déjà vu* and *24 Hour Psycho*, also included in the exhibition.

The second show to feature *Déjà vu* was *Black Spot*, held at Tate Liverpool later the same year, in which *D.O.A.*'s thematic concern with foreknowledge was the more prominent feature, along with its tale of death. The exhibition included the first of several *Black Spot* works featuring a small black circle on the palm of a hand. Gordon makes reference once again to Robert Louis Stevenson, in whose classic adventure tale *Treasure Island* (1883) the black spot is a portent of imminent, unavoidable death. A companion piece for the Black Spot series is a monitor-based video work, *Don't Think About It* 2001 (fig.85), showing a hand repeatedly slamming onto the camera lens, as if it were trying to resist or suppress something. Alternately blocking out light and letting it in, it is a visual metaphor for refusal and acceptance, what you choose to shut out from or admit to experience. Accompanying this work were *Something between my mouth and your ear* (fig.23), *30 Seconds Text* (figs.48–50) and *From God to Nothing* (figs.59–60), all of which focus on the formation and operation of the psyche. A new group of photographs, *Never, Never* 2000 (figs.86–7) returned to the body as the site of inscription. The group of eight images show a tattooed inner forearm, bearing the word 'forever'. They were displayed in four pairs of positive and negative prints,

NEVER, NEVER 2000 [87]
C-Print
61 x 76 (24 x 30)
Courtesy of the artist and Lisson
Gallery, London

BLACK SPOT 2000 [88]
Black and white photograph
76 x 76 (30 x 30)
Courtesy of the artist and Lisson
Gallery, London

each bracketing the corners of a room, the word appearing both black and white, forwards and backwards. It is a relatively simple formation, but one that nonetheless accommodates substantial complexity, for it is difficult to establish which is the actual, true subject of the photograph. What appears to be a positive image shows the word in white, when we know a tattoo should be black. There are in fact two original images of two arms, both Gordon's – with 'forever' in black on the left arm, and in white, written backwards, on the right, as if it were a shadow or imprint of the other. The tattoos are in themselves somewhat tautological, proclaiming as they do only the principal characteristic of their state – its permanence. But they cannot be read without an awareness of the word's frequent use in tattoos, normally preceded by the name of a loved one, a determinedly insistent declaration of emotional permanence that can only be hoped for rather than known with certainty. As with the phrases in the earlier *Letters* (figs.11–12) and *Instructions* (fig.13) this simple word can be interpreted as positive or negative, comforting or threatening. When inscribed and repeated, it comes to hover on the brink of unreasonable excess.

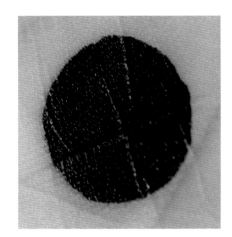

Such circularity, inversion, doubling and mirroring as is generated in *Never, Never* is a function of Gordon's abiding desire to carve out space and time between things, to allow some kind of suspension, a refusal of finality or resolution that has increasingly spilled out of the works themselves and into the spaces devised to house them. Gordon has begun to include large mirrors in his exhibitions, reflecting works and viewers alike, and augmenting the sense of spatial disorientation that many of the video installations engender. A vast mirrored wall stood at the outset of his major solo show at the Hayward Gallery, London, in late 2002, presenting a reflection of

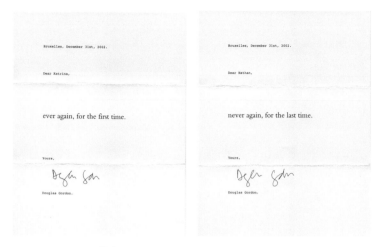

LETTER NUMBER 21 2002 [89]
Print on paper
Collection of the author

SCRATCH HITHER 2002 [90]
Video installation
Dimensions variable
Courtesy of the artist

SCRATCH HITHER 2002 [91]
Video installation
Dimensions variable
Installation view: 'what have I done',
Hayward Gallery, London 2002
Courtesy of the artist

24 Hour Psycho (fig.1) projected onto a screen suspended in a blood red room. The mirror allowed the viewer not only to see the film as if from the other side, but also to watch other people in the space at one remove, doubling up on the voyeurism of the film itself. The same mirror also reflected *Fog* 2002 installed in an adjacent space, its perpetually turning, receding and advancing expressionless figure amplifying the mood of suspense and endless present set up by *24 Hour Psycho*. Between these two large-scale projected works lay a trio of monitor-based videos that, encountered one after the other, enacted the kind of push-pull dynamic so prevalent in Gordon's work, the interplay of attraction and repulsion that he spoke about as being at work in *10ms⁻¹* (fig.29). The first was *Don't Think About It* (fig.85), the hand seeming to repel your approach. Turning from this, the second piece appeared across the floor: *Scratch Hither* 2002 (figs.90–1), showing another hand, this time with forefinger beckoning. By the time you reached it, however, the evenly paced, repeated movement had begun to seem strange, compulsive, not quite so enticing. Immediately behind this, and back-to-back with *Don't think about it*, was *Blue* (fig.68), with its two interactive hands, the most sexual of the three works, shamefully facing the corner.

This sequence of works is characteristic of the increasing spatial involvement Gordon employs in his installations. Further into the exhibition a new text work repeats the words *I've changed, You've changed* 2002, written repeatedly and at eye level along the full length of another mirrored wall. Employing the recognisable language of relationship breakdown, emotional crisis, an acknowledgement of the passage of time, the words implicate the viewer and his/her relationship to the artist. The mirror reflects not only the gallery visitors but, in this particular installation, also the newly re-born

Monster (fig.58). In the mirror the 'sequence' from normal to monstrous appears as in its original version, but in turning away from the mirror to the actual image, the monstrous, deformed face this time appears on the left. This use of mirrors adds further resonance to the layers of the works that they reflect, as if seen from Alice's perspective. The endless bringing into question of the original, the continual reiteration of the opposite, leaves the viewer suspended, occupying the uncertain middle ground sought after by Gordon.

The Hayward exhibition was entitled *what have I done*, a phrase that first appeared in Gordon's work as a *Letter* sent in 1994. In its original context, it brings about a potential complicity between artist and receiver, seeking shared knowledge or even justification. It is a familiar expression made at the moment of horrified recognition of wrong-doing and its ramifications. As exhibition title, it slips into a less malevolent tone, more inclined to collude with the expectations of autobiography brought to any such major solo show. The exhibition as a whole played on this further, suggesting a cumulative depiction of the artist. Several works comprise images of Gordon himself, including *Monster*, *Self-portrait (Kissing with Scopolamine)* (fig.25) and *A Divided Self I and II* (fig.51), or others who might be him, such as *Fog* (fig.95) and *Three Inches (Black)* (figs.65–6). For the first time we hear his voice, reciting the first-person narrative part of Hogg's *Private Memoirs and Confessions of a Justified Sinner* (fig.93) in *Black Star* 2002 (fig.94); and the pointedly autobiographical *Something between my mouth and your ear* (fig.23) and the similarly relational *I've changed, You've changed*, together insist on the constant proximity of the artist. The self-descriptive *Pretty much every film and video work from about 1992 until now. To be seen on monitors, some with headphones, others run*

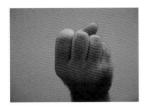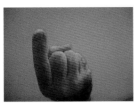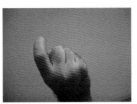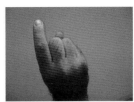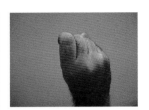

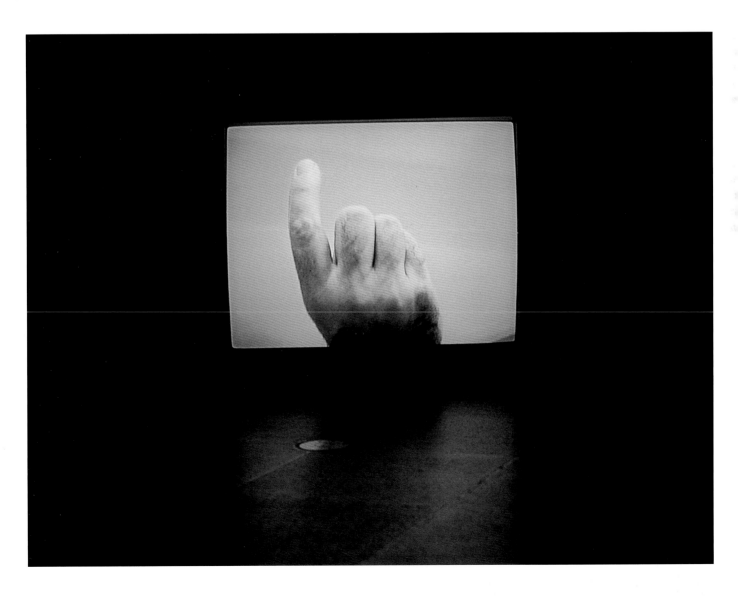

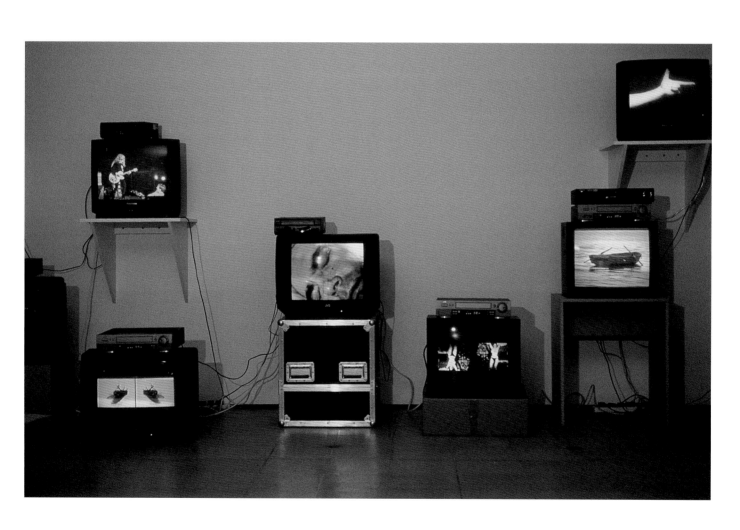

silently, and all simultaneously 2002 (fig.92), seemed to provide one answer to the implied question of the show's title. But if, to use the title of another work, *Left is right and right is wrong and left is wrong and right is right* (figs.73–4), can anything meaning-fully or accurately be inferred from what is shown to us? Are our assumptions and interpretations of the persona behind these works viable? The mirrors don't just reflect the works; they also show us ourselves, reflecting our desires back at us, resisting at the same time as absorbing our presence. The experience of the work becomes one of inter-penetration, seeing oneself and others incorporated into the work.

Gordon's art offers primarily visual experiences, for even those works in which audio is the dominant component include strong visual elements, whether colour or light. They depend on and acknowledge sight as our privileged sense, as well as showing how readily our eyes can deceive us, thanks to the involvement of memory in the process of interpretation. They offer physical experiences, with a range of carefully selected and controlled triggers intended to stimulate and provoke, but what ensues is the true place in which the art lies. Gordon's work is concerned foremost with subjectivity, diversity and mutability, with tipping over to the opposite extreme just when things seem to coalesce around one perspective. This desire for a kind of shape-shifting, typified by the continual Jekyll–Hyde metamorphosis of *Confessions of a Justified Sinner* (fig.54), defies the irresistible desire to understand the world by fixing and defining it that is fundamental to how we establish control.

A perpetual refusal of the single viewpoint permeates Gordon's most recent *Letters*, which exist in pairs. *Letter Number 20* is in fact two letters sent on the same date, 28 September 2002, from two geographically distant places. From New York came 'I'm closer than you think' and from Porto 'You're closer than you know'. Sent on the last day of 2002, the turn of the year and the traditional moment for both reflection and looking forward, *Letter Number 21* (fig.89) is two letters mailed to couples living at the same address, one reading 'never again, for the last time' and the other 'ever again, for the first time'. Gordon is still seeking that space 'in your head', trying to carve out a space between fact and fantasy in which to operate. He is happy to abduct material from whatever source in whatever form to provide the necessary triggers, relishing art's ability to bring diverse elements into co-existence and co-operation, through varied forms and structures. For Gordon's ideas can be embodied equally well in a simple letter or a large-scale complex video installation. Their shared objective is to coax us away from the comforting certainty of easy definitions and extreme positions. Whatever scale or form he adopts, he insists on the body as the site of the work's unfolding and the mind as the space of its life.

THE MEMOIRS AND CONFESSIONS
OF A JUSTIFIED SINNER 2002 [93]
Heidelberg Press
Installation view: Kunsthaus Bregenz
2002
Courtesy of the artist and Kunsthaus
Bregenz

KATRINA BROWN Your exhibition in Bregenz included three major new pieces, all of which are related to James Hogg's *Confessions of a Justified Sinner*. The first floor was converted into a kind of infernal print shop, reproducing your own hand-written transcript of 'The Confessions' section of the book (fig.93). The second floor became *Black Star* (fig.94), a pitch-black space with ultra-white light delineating the five points of a star, in which a voice reads the same text. The third floor was occupied by *Fog* (fig.95), a vast video projection using imagery based on a scene in the book. How much of an obsession has the text become and why?

DOUGLAS GORDON *People used to occasionally ask me why I was obsessed with Hitchcock. I always denied it until it happened so many times that I began to realise that maybe there was some truth in it. I was more conscious of the enjoyment I had in the Hogg, probably because I came to it when I was older, whereas the interest in Hitchcock was like a seed planted earlier on. I'd been reading a lot about Jekyll & Hyde when making the piece that came to be called* The Confessions of a Justified Sinner *and I stumbled on it in a critique of Stevenson. Hogg was mentioned so many times that it led me on to read the book and other criticisms of it. This was in 1995–6, a period in my life when I found it enjoyable to fantasise that I might even be living one of the characters' lives, a version of a novel written 200 years before that I was completely unconscious of. That's as much of an obsession as I would admit to.*

KB You also clearly enjoy the way in which the book plays around with the idea of authorship: the unidentified narrator/editor framing Wringhim's Confessions as well as the various bits of supposedly factual evidence cited in support of the tale's veracity.

DG *What I loved about the book, which became part of the exhibition, was that there's enough space and anonymity in the way that the fiction is told that you could imagine that you could almost pass yourself off as one of the characters or authors. The fantasy idea I had for Bregenz came from one point in the book where Wringhim has finally realised his descent into madness; he tries to warn the world of the dangers of flirting with the devil, by writing his Confessions, but no one will print them. I liked the idea that I could actually involve a whole printing apprenticeship in order to realise something that couldn't even be realised in the fiction because it was so diabolical. It mirrors what I did with the* Empire *sign (fig.76): making a fictional element real. This was going even further though, because I was doing something that couldn't even be done in the fiction.*

KB Hogg's fiction, of course, slips into fact at certain points. The text, which was initially published anonymously, quotes a letter that appeared in an Edinburgh literary review the year prior to the book, signed by 'a James Hogg'.

DG *Yes, that provokes a confusion where you don't really know if you're reading something by Hogg in the first place. There are various stories about why he did that – whether it really was an intellectual intrigue, or more about his ego, or in order to distance himself from a book that really needed to be published but was bound to be criticised by the church.*

KB Although the three pieces can and do stand alone, the relationship between them was particularly vital at Kunsthaus Bregenz, especially as it mirrored the three-part structure of Hogg's book. You talked about the space in a similar way to how you described the underpass in Münster – that the three levels of the gallery offered a model of hell, purgatory and heaven. That's quite a Catholic structure for the setting of work that draws on a critique of Calvinist predestination.

DG *Growing up with some idea of Catholicism as exotic, I was always interested in purgatory. Not that I believed in heaven or hell; I was much more interested in the purgatory idea and the fact that it became a powerful political and economic means for the Catholic church to control people. If you were destined to hell you could give up, but the fact that your family could pay for you to be taken out of purgatory became a much more interesting idea than being consigned to hell or elevated to heaven. It's such a Protestant idea that life on earth is purgatory but Catholicism moved it into another realm. The idea of indecision, or postponing a decision, therefore becomes more interesting to me than to make an absolute commitment to anything. There are those who have immediate ascension, and those who are still waiting for judgement. The thing that intrigued me was the*

half-full/half-empty; people who are quite bad but not bad enough, and quite good but not good enough – how do they float about in purgatory and have a discussion together?

In Bregenz, we could start off with the word and end up with the image. The logical conclusion was for the in-between space to have almost no image, but words that are not legible, not present or concrete.

KB So to what extent did the context of Bregenz – both the particular architecture of the Kunsthaus and the broader context of the town by the lake – help shape the form and atmosphere of the exhibition, the coming together of the three elements?

DG *It's important with projects like this and* Between Darkness and Light, *that on the one hand they offer an opportunity to work in a situation where you can allow yourself to be provoked by the social, cultural, architectural context. The mythology that I learned about when I made my visits to Bregenz was the 'spirits of the lake', ghosts, the phenomenon of the fog that is almost year-round. Those things could have talked me out of what I'd originally been thinking of doing, but the confirmation came when I saw Peter Zumthor's architecture, which is all about making the viewer know exactly where they are. So the obvious thing for me to do was to go against that logic, to make one space into a kind of perverse industry, for example. Where the rest of the art world seemed to be making old factories into new artspaces, I was trying to make a new art space into an old factory! Then to build the shape of a pentagram right in the middle of Zumthor's logic was on the one hand a nod of respect towards his rationality but on the other an attempt to introduce something esoteric or verging on the occult, where even in that logical space the seed of doubt is sown. Once you were in the* Black Star, *the fact that you knew you were in a Zumthor cube was cold comfort.*

KB What happened with *Black Star* was that you became completely disorientated, as you say. Even in the midst of this incredibly logical, rectilinear structure, you found yourself in a space with no easy markers, no usable footholds. You literally became lost in the space.

DG *What happened physically – even for me, having worked from Glasgow on the space, making plans, knowing what they were constructing and so on – was that, when I got to Bregenz, within two seconds of going into that space I didn't know what was going on or where I'd come from. I couldn't see the entrance any more, or the exit. Although that was quite a discomforting experience, it's exactly what a lot*

of my work has been trying to court. It reminded me of things like I remember nothing, I have forgotten everything *(fig.19) and so on.*

KB It also prioritises experience over knowledge and control. It all comes down to subjective physical experience.

DG *Yes, it's also designing something that's way outside your ken. Although there is a control aspect to the way I work, there's also desire to let it go . . . a bit.*

KB For all the star's regularity it has no rectilinear ease of use, and added to this unease is of course the occult association, the belief that you can summon the devil from its centre.

DG *The occult thing became a kind of side joke, but it was more about the beautiful principle that no matter how sophisticated a person is, when you give them a simple yet sophisticated shape, they find it much harder to recognise what that shape is when they're in it than when they're outside it. That became a very strong metaphor. It's a parallel experience to reading a book like* The Confessions . . . *where the deeper into it you get, the more you realise no one has the full story, even though you have this supposedly logical narrative of the editor. The metaphor being that the deeper into anything you get, the less you know where you are.*
With the light effect, I was trying to make sure it was a light that, given an environment in which there was no reflective surface, when a person walked into that space, all of the light would cluster, almost in the Medieval sense that light is not just rays, but a living force. The effect is disturbing and intriguing.

KB The sheer density of the darkness in *Black Star* meant that it became a kind of crux in the whole experience. There's so little visual information or physical orientation to be had, and this seemed to highlight the fact that fears and fantasies live inside you, that they're all in your head. I suppose it's related to *Something between my mouth and your ear* (fig.23), but it also seems close to *From God to Nothing* (figs.59–60).

DG *It's something to do with fear and dark spaces, the weird fact that, especially when you're a child, when you're in a space and the lights go out, the first thing you do is to close your eyes. That just makes it worse! I love the idea that you try to fight dark with dark.*

KB But isn't that partly to do with trying to introduce some kind of membrane between you and this space you don't want to inhabit? The only way you can extract yourself from it is in your imagination. As long as you're getting

FOG 2001 [95]
Video installation
Dimensions variable
Installation view: Kunsthaus Bregenz 2002
Courtesy of the artist and Kunsthaus Bregenz

information through your eyes ...

DG *... You're subject to some external thing, until you start dreaming.*
I was thinking about who I'd most like to meet in a space like Black Star *– I suppose myself coming in the other way. That would set up something interesting. People talk about Jekyll and Hyde, say, as equivalents. But, if that kind of split could really happen, it couldn't be true. There's always an imbalance; evil, the darker side, inevitably becomes more powerful. One of the appealing things about the idea of your doppelgänger being more powerful than you is because the bad can adopt good as a disguise, but a good person cannot adopt evil. You can't pick it up and throw it away. Evil is meant to be innate, but goodness is something evil can adopt at any moment.*

KB The final piece is the vast two-sided video projection *Fog* (fig.95), which is very much about this fantasy of coming across your doppelgänger. Each projection shows a figure continuously emerging from and disappearing into fog, which, when combined on screen with the other projection, makes it appear as if he's merging with himself/his double. I remember the silence of it being almost unbearable after the noise of the printing press and the voice of *Black Star*, which seemed to get right inside your head. The disembodied voice was replaced by something more physical and maybe recognisable, but strangely intangible. It was about light and image, but completely silent in a way that was quite striking.

DG *It's interesting you think of it as about light. I expected it to be about darkness, but that was before I realised the density of* Black Star. *I had always intended there to be a mix-up between the three spaces.*

KB It seems quite important, given what you said about slipping into one of the voices/characters in Hogg's text, that the figure who appears in *Fog* could be mistaken for you.

DG *It wasn't deliberate. I was thinking of using someone else, who looked like the character in the Kenneth Anger film,* The Invocation of My Demon Brother. *When he couldn't do it, I thought about who could be the invocation of my demon bother, and thought well, maybe Gary Rough. Partly through having lived in the same cities, partly through a language thing, we probably could pass for brothers, to people who don't know us. It's definitely part of the game and part of the mythology.*

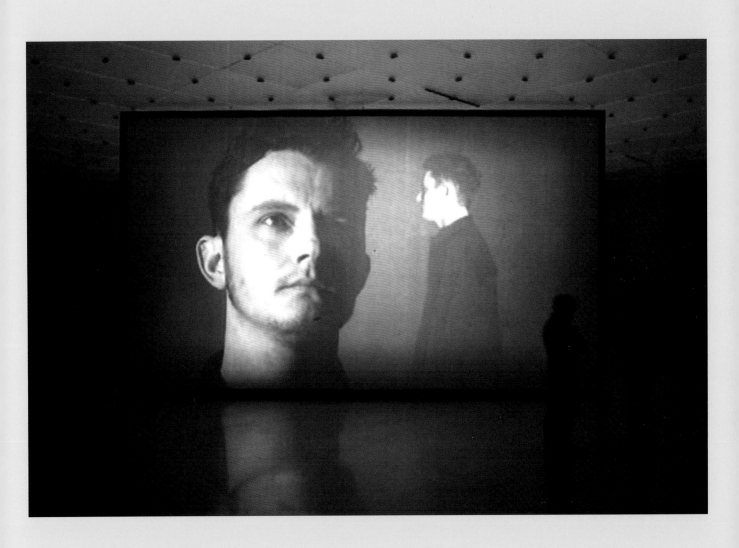

Our manifest cultural fascination with sinister alter egos, with doubles and split personalities, ideas that challenge the conception of each of us as unique, identifiable beings, runs throughout Gordon's work. In examining the origins of this cultural fascination, we can see how Gordon's techniques of splitting, mirroring and the use of metamorphosis, which invite us to look at what happens when there's a glitch, a slippage, in the relationship between body and mind, have strong roots in themes prevalent in Scottish literature from the nineteenth century onwards.

In works of fiction, such malfunctions are the ideal vehicles for fantasy, allowing the introduction of something out of the ordinary in the midst of an otherwise acceptable and familiar world. In his brilliant study *Doubles: Studies in Literary History* (Oxford 1985), Karl Miller explores the continued prevalence in literature of what he refers to as 'the dynamic metaphor of the second self', from the conception of the 'doppelgänger' in German Romantic literature of the late eighteenth century to the present day. It can also be found in recent films, most notably *Fight Club* (David Fincher, 1999) (fig.100), which tracks the destructive relationship between a previously normal, conforming citizen (Ed Norton) and his anarchic, demonic cohort (Brad Pitt). Their meeting triggers a spiralling conflict between the controlled and the reckless, the socialised and the psychopath. It is a conflict, which, like Henry Jekyll's, is ultimately fatal, as the schism between the two becomes intolerable. The explanation – in psycho-analytic terms – for the creation of such alter egos is generally as a release for an aspect of personality that has been in some way suppressed, by family, society or some other controlling mechanism. While it is a theme with universal resonance, it is also peculiarly Scottish and most widely recognised in Robert Louis Stevenson's classic horror story *The Strange Case of Dr Jekyll & Mr Hyde* (1886).

Written in 1885 in a 'white-hot haste' – over three days after a fever-induced dream – the book is both thematically and structurally concerned with doubling, division and multiple voices. These ideas were to fascinate Stevenson and feature prominently in his work throughout his short but successful career. The story comprises an account by an anonymous narrator, letters between some of the main characters and a first-person narrative by Jekyll himself, all offering various perspectives on the unfolding events. Thematically it is a powerful allegory about the struggle between good and evil. The conflict is typified by Dr Jekyll's own description of the two selves he has become in the final section of the story, his 'Statement of the Case': 'Even as good shone upon the countenance of one, evil was written broadly and plainly on the face of the other.' The rational, cultured doctor goes on to recount how he brought the monstrous, murderous Hyde into being. His sinister alter ego, embodied as Hyde, has been released from his psyche into the world thanks to a mysterious potion concocted by Jekyll in his enthusiastic and determined pursuit of knowledge, described by others in the narrative as 'unscientific balderdash'. The two opposing characters struggle for dominance of one body, that of the 'good' Dr Jekyll.

This setting of controversial scientific enquiry makes Stevenson's story very much of its time. The influential and wide-ranging impact of Charles Darwin's *On the Origin of Species* (published in 1859) can be discerned in Stephenson's depiction of man's tendency towards bestial behaviour. Yet it also looks forward to Sigmund Freud's work on the structure

CONFESSIONS OF A JUSTIFIED
SINNER 1995–6 [96]
Video installation
Two parts, each 122 x 92 (48 x 36 ¼)
Installation view: 'Turner Prize 1996',
Tate Gallery, London
Collection Fondation Cartier pour
l'Art Contemporain, Paris
Courtesy of the artist and
Lisson Gallery, London

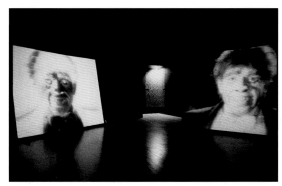

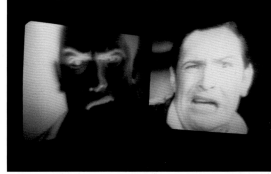

and operation of the human mind. In many ways it is an extraordinarily prescient fictional precursor to the developments made by Freud and others in the first half of the twentieth century in human psychology and psychiatry, which have fundamentally shaped our understanding of the split personality: the being who cannot perceive him/herself as unified under a single 'I'. As has been suggested by Mark Currie in his compelling recent analysis of Stevenson's story, 'True Lies: Unreliable Identities in Dr Jekyll and Mr Hyde' (*Postmodern Narrative Theory*, London 1998), this understanding applies not only to its description of an irreconcilable split in one being, but also to the way in which Jekyll tells his own story. This process, effectively one of self-narration comparable to the basis of psychoanalysis, takes the subject from self-ignorance to self-knowledge:

> I thus drew steadily nearer to that truth, by whose partial discovery I have been doomed to such a dreadful shipwreck: that man is not truly one, but truly two. I say two, because the state of my own knowledge does not pass beyond that point. Others will follow, others will outstrip me on the same lines; and I hazard the guess that man will be ultimately known for a mere polity of multifarious, incongruous and independent denizens.

It can also be seen to mirror Freud's eventual differentiation between the id (the primal, base drives and those things repressed by consciousness), the ego (which deals with external reality and social interaction) and the superego (the conscience or the internal moral judge). Seen in these terms, the Jekyll whose story we are told by the narrator is the ego, Hyde is the id and Jekyll, in his later role as narrator delivering his 'Statement of the Case', is the superego. Stevenson was, however, writing many years before Freud developed his theories on the subconscious and the various factors in human behaviour. In 1885–6, Freud was still studying under Jean-Martin Charcot at the Salpêtrière in Paris and it would be a full ten years before he used the term 'psychoanalysis' for the first time.

This said, Stevenson's work is first and foremost a gripping horror story that has transcended its particular time to become a timeless classic, the best-known and loved of the many works of fiction that rely on the concept of 'a divided self'. At the time he was writing, Stevenson could have had no idea of the extent to which his extraordinary double character would become one of the most enduring literary creations of the nineteenth century, with a cultural resonance and appeal far beyond its time and place of origin. His story has provided the basis for over twenty films, with Jekyll/Hyde played by the most celebrated actors of their times, from John Barrymore to Spencer Tracy, Kirk Douglas and Michael Caine. At the other end of the spectrum, there has even been a musical version, starring none other than David Hasselhoff and the inevitable trans-sexual version, *Dr Jekyll and Sister Hyde* (fig.97).

The fame of Stevenson's tale has perhaps obscured the fact that it had an important precedent, the lesser-known but similarly themed and structured work by fellow Scotsman, James Hogg. Hogg himself was something of a dichotomy: on the one hand he was a cultured Edinburgh man of letters, on the other a simple man of nature, a farmer from the Borders, known as 'The Ettrick Shepherd'. His most famous work, *The Private Memoirs and Confessions of a Justified Sinner* (fig.98), shares much with Stevenson's tale. We have seen how both works together provided

Jekyll and Hyde – The Musical directed by Don Roy King and starring David Hasselhoff 2001 [97]

the basis for Gordon's *Confessions of a Justified Sinner* (fig.96), in which his continuous looping of the moment of Dr Jekyll's transformation into Mr Hyde (taken from Mamoulian's 1932 screen version) continually denies the viewer the possibility of an absolute, graspable vision of either 'good' or 'evil'. First published anonymously in 1824, at a time when many would still have believed that the devil walked among them, Hogg's book tells the story of Robert Wringhim: his upbringing according to strict Calvinist doctrine, his friendship with the strange Gil-Martin and his eventual ruin. Wringhim first encounters his mentor shortly after he has been accepted into the 'society of the just made perfect', the chosen elite who, according to his particular brand of Calvinism, are destined to join God in heaven regardless of their actions on earth. He recounts:

> I was now a justified person, adopted among the number of God's children – my name written in the Lamb's book of life, and that no bypast transgression, nor any future act of my own, or of other men, could be instrumental in altering the decree.

The book offers an extreme vision of what this belief in the existence of an infallible elect might lead to. The chameleon-like, demonic Gil-Martin persuades Wringhim to engage in deeds that are far from righteous, cunningly and manipulatively using the Bible as his justification at every turn.

The concept of division and segregation between good and evil at the heart of the story is further amplified by the extent to which Gil-Martin is perceived as Wringhim's double, his own doppelgänger. When they first meet, Wringhim explains: 'I felt a sort of invisible power that drew me towards him . . . What was my astonishment on perceiving that he was the same being as myself!' Later, this doubling of self becomes a fracture of self, as Wringhim increasingly understands himself as split in two: 'I approved of it in theory, but my spirit stood aloof in practice'; 'I generally conceived myself to be two people'; 'It is impossible that I can have been doing a thing and not doing it at the same time . . . I have a second self'; 'my body and soul were become terrors to each other'.

Structurally, Hogg's tale is recounted by two main voices: those of an anonymous narrator and of Wringhim himself. Like *Jekyll & Hyde*, it includes a first-person confession, Wringhim's account of the events that led to his demise, including the murder of his own brother, George Colwan. The reader therefore sees his life from two distinct perspectives, the first being that of the supposedly objective and insistently fact-bound narrator, who clearly tends to sympathise with Colwan. In a further layering of the text, the narrator claims to have recovered Wringhim's confession – in part printed, but concluded by hand – from the grave of an anonymous suicide. Wringhim, we are told, had worked briefly for a printer and had attempted to disseminate his story in the form of a pamphlet. When the horrified printer discovered its content, he found it to be 'a medley of lies and blasphemy' and had all copies destroyed. The narrator's introduction to the final part of the tale repeatedly insists on its veracity:

> Attend to the sequel, which is a thing so extraordinary, so unprecedented, and so far out of the common course of human events, that if there were not hundreds of living witnesses to attest the truth of it, I would not bid any rational being believe it.

Cover of 1897 Penguin Classics edition of James Hogg's *The Private Memoirs and Confessions of a Justified Sinner*, showing a portrait of the author by Sir John Watson Gordon [98]

Cover of 1961 Penguin Classics edition of Choderlos de Laclos's *Les Liaisons dangereuses* [99]

In addition to the voice of the narrator, the text at one point includes a letter written by 'a James Hogg' that also appeared in *Blackwood's Magazine* in August 1823, and which the narrator of *Confessions* tells us 'bears the stamp of authenticity in every line'. It is an extraordinary piece of metafiction, contributing substantially to the text's plausibility that also presumably acted as a great piece of advance publicity. This technique of authenticating, the intertwining of fact and fiction, was developed in the epistolary format popularised in the late eighteenth century by, among others, Choderlos de Laclos's *Les Liaisons dangereuses* (1782) (fig.99) and Jean-Jacques Rousseau's *La Nouvelle Hélöise* (1761). Both Laclos and Rousseau adopted techniques that sought to make the reader forget he or she was reading a work of fiction, claiming to present found letters written by real characters, unknown to the narrators.

The epistolary format used by Laclos, which has allowed *Les Liaisons dangereuses* to be described alternately as deeply moral and distinctly amoral, contains two main attributes that were of value and relevance throughout nineteenth-century fiction. The first of these is the multiple voices of the diverse letter writers, whose tone, language, style and register form the mechanics of character portrayal in the absence of a ubiquitous narrator. These voices provide the reader with differing, even conflicting, perspectives on the same events and emotions. The second is that of framing the tale with the voice of the finder/narrator/ editor/publisher, which allows the real author some distance and scope for comment and/or condemnation that inscribes these texts with moral ambiguity and doubt. Hogg exploited both, combining the editor's narrative as his framing device and what he presents as Wringhim's found confession, as well as using both

Scots and English language in the characters' dialogue. Hogg's book also shares with Laclos a distinct moral ambiguity. While they each arguably hold a mirror up to society to warn of the dangers of extremism – Calvinist concepts of predestination in nineteenth-century Scotland and Libertinism in pre-Revolutionary France – as works of fiction, they also play to and rely on the readers' appetite for horror, scandal and outrage.

Hogg was born in Ettrick Forest in the Scottish Borders in 1770, moved to Edinburgh to pursue a literary career in 1810 and died in 1835. Stevenson was born in Edinburgh in 1850, studied engineering and law before turning to writing full time and travelled widely before settling in Samoa, where he died in 1894. Though the two led very different lives and clearly never met, nor even coincided, they remain connected by the specific context of nineteenth-century Scotland. Beyond their mutual employment of the dual personality, they further share the depiction of bodily form given to the abstract concept of evil and the capacity for its exercise even in those who appear righteous, civilised and law-abiding. Jekyll is a respected and well-liked doctor; Wringhim has been inculcated with religious piety from an early age. Yet both protagonists commit murder.

Stevenson attributed much of his fascination with notions of doubling and division to the particular context of his native Scotland. He once wrote that it is a country that 'has no unity except on the map. Two languages, many dialects, innumerable forms of piety, and countless local patriotisms and prejudices, part us among ourselves more widely than the extreme east and west of that great continent of America.' (*The Scot Abroad*, London 1883). Scotland had been riven by the Reformation into Catholic and Protestant, with many ensuing sub-divisions. It had been courted by and

connected with both England and France, whose influence is manifest in the appearance of English and French words in the Scots language. For writers in particular, an especially potent factor was the co-existence of both English and Scots languages in this post-Union and pre-broadcast media era. English had, since the Act of Union and the dissolution of the Scottish parliament in 1707, become the language of the court and therefore of the ruling, land-owning and educated classes. It was increasingly permeating society, with Scots gradually marginalised, perceived as indicative of a simple, low and uneducated background. While Stevenson wrote predominantly in English, albeit a hybrid Scots-English, he frequently used Scots for individual characters, often to suggest particular intimacy, moments of vulnerability when the speaker reverts from adopted to native tongue, creating two distinct registers in which the multiple voices in the texts are presented.

Stevenson's last work, the unfinished novel *Weir of Hermiston*, on which he was working when he died in 1894, tells the story of the conflict between young Archie Weir and his father, 'two men more radically strangers', emphasised in their differing language. Lord Justice Weir uses broadest Scots, while his son uses polite English, except in those moments where his emotions are truly roused. There is also a stark contrast between the two influential characters in Archie's life; Kirstie, the housekeeper, uses broad Scots, while Frank Innes, his Mephistophelean friend, speaks only the most refined English, not belonging to the rural setting in which the story unfolds.

The ability to adopt differing voices is a practice that persists through contemporary Scottish fiction. The most extreme manifestation of the vernacular is its near exclusive use for the singular voice of Sammy in James Kelman's Booker Prize winning *How late it was, how late* (1994), punctuated only occasionally by doctors and social workers who speak in a different tongue. The conflict between the two tongues is the basis for the horrific *Marabou Stork Nightmares* (1995) by Irvine Welsh. Welsh uses two linguistic registers for one character, Roy Strang – one his 'real' voice, as he narrates his thoughts and memories, the other his 'fantasy' self in the dream world he occupies while in a coma. Like Stevenson, Welsh presents us with good and bad aspects of the same being, though as the story progresses, the two increasingly intertwine and overlap, finally coming together irrevocably just before Strang is killed. Meanwhile, author Ian Rankin recently revisited the themes of 'Jekyll and Hyde' in his novel *Hide and Seek* (1998), featuring his popular detective John Rebus and a selection of corrupt lawyers and police officers, alongside kind-hearted criminals. In updating the story he suggests that the opposing forces are not in fact absolute, but rather co-dependent and necessarily co-existent in one and the same being. What underpins the horror of Hogg's and Stevenson's texts, as well as that of Rankin, is the realisation that there is the capacity for both in all of us. The good are not all good nor the bad necessarily all bad. More generally the intermingling of fantasy and reality that Hogg, Laclos and others made use of may now be transposed into the form of the docu-drama, that largely televisual genre that uses some fact to make a compelling, convincing drama, often at the expense of historical accuracy.

The continuing play of diverse voices and the enduring fascination with the incarnation of evil that permeates Scottish literature has clearly made its mark on Gordon's work, as has a much boader interest in the relationship between the real and the unreal. The

Ed Norton and Brad Pitt in David Fincher's film *Fight Club*, 1999 [100]

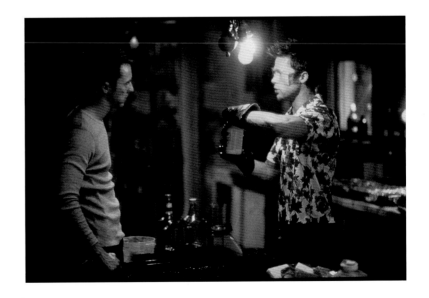

knowing, cunning play with fact and fiction, the creation and development of intrigue, and the ability to make someone believe in something, lies at the heart of all of these works of fiction, which in turn serve to feed our own imaginations. What these tactics all seek to achieve, wherever and however they appear, is to lend credence to the story being told, to suggest that the 'architecture of lies' that comprises any fiction is based in reality. The narrated events become all the more horrifying as they slip into the realm of the possible, unable to be confidently dismissed as unreal, while the use of documentary elements underscores the extent to which our fantasies and fears, however imaginative, are necessarily constructed from our remembered past, be it in fact or fiction. The songs we hear, books we read, movies we watch, play as much of a role in those as our own personal experiences. These are the things that dreams – and nightmares – are made of.

In Douglas Gordon's *Short Biography – by a friend*, the anonymous narrator recounts how during his time in Berlin, he lived by night, seldom emerged during daylight and started to tell people that 'he had actually seen the devil in a café'. Another text, published in the catalogue for the 1997 Berlin Biennial, claims its author first met the devil 'in a roadside diner, somewhere between Los Angeles and Palm Springs. If I tell you that I did not recognise him immediately, I can imagine that I might seem naïve.' I know he (Gordon – not the devil) and I met in a bar in Glasgow in 1990 and I think we talked about *Faust*, that scene just before Mephistopheles appears to bargain for Faust's soul. I don't know if he, or anyone, really has met the devil, or if he just thinks he has, but I know for sure he likes the idea of it.

THROUGH A LOOKING GLASS
1999 [101]
Video installation
Dimensions variable
Installation view: Gagosian Gallery
(SoHo), New York 1999
Astrup Fearnley Museet, Oslo
Courtesy of the artist and Gagosian
Gallery, New York

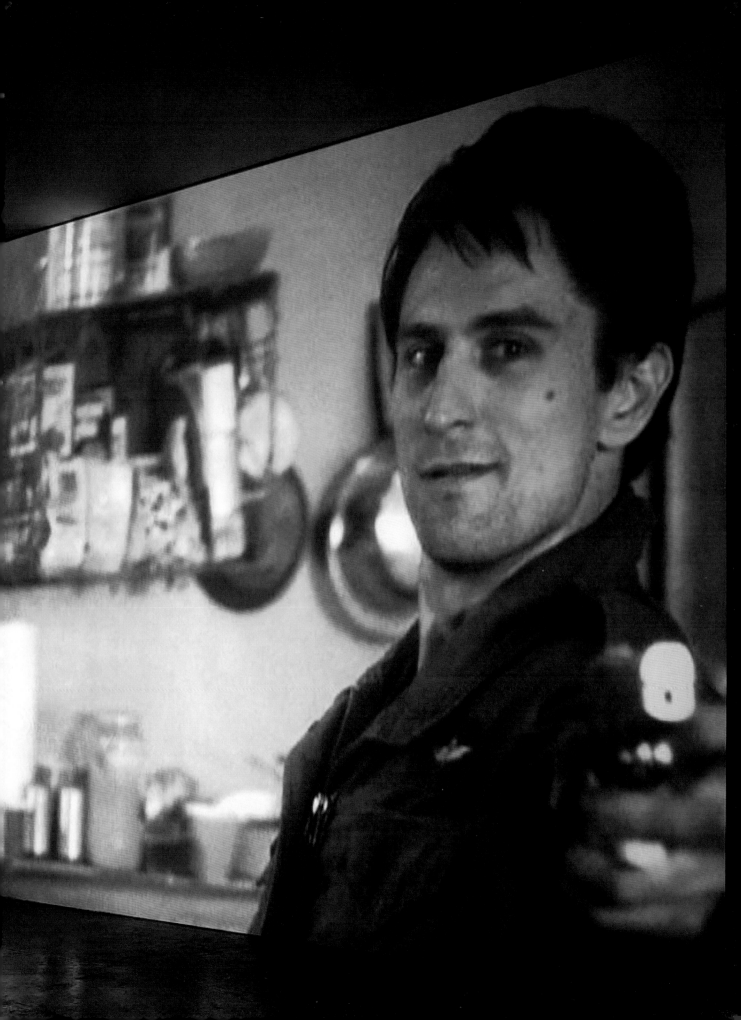

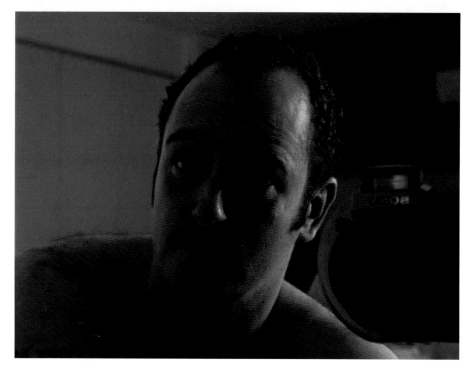

Biography

1966 Born in Glasgow
1984–88 Glasgow School of Art
1988–90 The Slade School of Art, London

Lives and works in Glasgow and New York

Solo Exhibitions

1993 *24 Hour Psycho*, Tramway, Glasgow and
 Kunst-Werke Berlin. Cat.
 Migrateur, ARC Musée d'Art Moderne
 de la Ville de Paris. Cat.
1994 Lisson Gallery, London
1995 *Bad Faith*, Künstlerhaus, Stuttgart
 Jukebox (with Graham Gussin),
 The Agency, London
 Entr'Acte 3, Stedelijk Van Abbemuseum,
 Eindhoven. Cat.
 Centre Georges Pompidou, Paris
 Rooseum Espresso, Malmö
1996 *Cinéma Liberté* (with Rirkrit Tiravanija),
 FRAC Languedoc-Roussillon, Montpellier
 24 Hour Psycho, Akademie der Bildenden
 Künste, Vienna
 … head, Uppsala Konstmuseum (part of
 Sawn-Off), Uppsala. Cat.
 Galleria Bonomo (part of British Art
 Festival), Rome
 Canberra Contemporary Art Space
 Migros Museum für Gegenwartskunst,
 Zurich. Cat.
 Galerie Walcheturm, Zurich
1997 Gallerie Nicolai Wallner, Copenhagen

Bloom Gallery, Amsterdam
Galerie Micheline Szwajcer, Antwerp
Skulptur. Projekte in Münster
Galerie Mot & Van den Boogaard, Brussels
Gandy Gallery, Prague
Douglas Gordon, Biennale de Lyon
5 Year Drive-By, Kunstverein Hannover
Leben nach dem Leben nach dem Leben,
Deutsches Museum Bonn, Bonn
1998 Kunstverein Hannover. Cat.
1999 Galeria Foksal, Warsaw
 Kölnischer Kunstverein, Cologne
 Neue Nationalgalerie, Berlin
 through a looking glass, Gagosian Gallery,
 New York (SoHo). Cat.
 Double Vision (with Stan Douglas),
 Dia Center for the Arts, New York. Cat.
 Centro Cultural de Belém, Lisbon. Cat.
 Harmony, Moderna Museet, Stockholm. Cat.
 Feature Film, Artangel, Atlantis
 Gallery, London; Kölnischer Kunstverein,
 Cologne; Centre Georges Pompidou,
 Paris. Cat.
2000 *black spot*, Tate Liverpool. Cat.
 Sheep and Goats, ARC Musée d'Art
 Moderne de la Ville de Paris. Cat.
2001 *Douglas Gordon*, MOCA at the Geffen
 Contemporary, Los Angeles; Vancouver
 Art Gallery. Cat.
 5 Year Drive-By, Twentynine Palms,
 California
 Lisson Gallery, London
 thirteen, Gagosian Gallery, New York
 (Chelsea)
 Sleeper, 6 Darnaway Street, Edinburgh

2002 *what have I done*, Hayward Gallery,
 London. Cat.
 Kunsthaus Bregenz
2003 Yvon Lambert, Paris

Selected Group Exhibitions

1990 *Sites/Positions*, throughout Glasgow
 Self Conscious State, Third Eye Centre,
 Glasgow. Cat.
1991 *Barclays Young Artist Award*, Serpentine
 Gallery, London
 Archive Project, APAC Centre d'Art
 Contemporain, Nevers
 London Road (with Roderick Buchanan),
 Orpheus Gallery, Belfast
 The Bellgrove Station Billboard Project,
 Glasgow
 Windfall '91, Seamen's Mission, Glasgow
 Walk On, Jack Tilton Gallery, New York;
 Fruitmarket Gallery, Edinburgh
1992 *L'U di carte*, Café Picasso, Rome
 Anomie, Patent House/Andrew Cross,
 London
 Speaker Project, Multiplici Culture, Rome
 Love at First Sight, The Showroom, London
 And What Do You Represent?, Anthony
 Reynolds Gallery, London
 Guilt by Association, Museum of Modern
 Art, Dublin. Cat.
 240 Minuten, Galerie Eshter Schipper,
 Cologne
 5 Dialogues, Museum of Natural History,
 Bergen
 Instructions, Studio Marconi, Milan
1993 *Purpose Built*, Real Art Ways, Hartford,
 Connecticut
 Before The Sound Of The Beep,
 soundworks throughout Paris
 Left Luggage/Rencontres dans un couloir,
 Maison Hanru, Paris
 Prospekt '93, Kunsthalle, Frankfurt
 Douglas Gordon – Simon Patterson,
 Galerie Gruppe Grün, Bremen
 Wonderful Life, Lisson Gallery, London
 Chambre 763, Hotel Carlton Palace, Paris
 High Fidelity (with Tom Gidley), Kohji
 Ogura Gallery, Nagoya; Röntgen Kunst
 Institut, Tokyo
1994 *WATT*, Witte de With & Kunsthal,
 Rotterdam
 Stains in Reality, Galerie Nicolai Wallner,
 Copenhagen
 Wall to Wall, South Bank Touring
 Exhibition; South Bank Centre, London;
 Leeds City Art Gallery, Leeds
 *Something between my mouth and your
 ear*, Dolphin Gallery, Oxford. Installation
 for *The Reading Room*, a project by Book
 Works, London

Rue des Marins, Air de Paris, Nice

Modern Art, Transmission Gallery, Glasgow

Gaze: l'Impossible transparence, Carré des Arts, Parc Floral de Paris

Conceptual Living, Rhizome, Amsterdam

New Painting, Chapter, Cardiff; Oriel Gallery, Mold

Europa '94, First European Gallerist Congress, Munich

The Institute of Cultural Anxiety: Works from the Collection, ICA, London. Cat.

Some of my friends, Galerie Campbells Occasionally, Copenhagen

Points de vue: Images d'Europe, Centre Georges Pompidou, Paris

1995
Eigen + Art at Independent Art Space, London

Kopfbahnhof/Terminal, Hauptbahnhof Leipzig, Leipzig

Take me (I'm yours), Serpentine Gallery, London and Kunsthalle, Nuremberg

Varje gång jag ser dig (Every time I see you), Stora Kvarngatan 34, Malmö

Chez l'un, L'AUTRE (1 + 2), 5 rue des Ursulines, Paris

General Release, British Council selection of Young British Artists, Scuola di San Pasquale, 46th Venice Biennale. Cat.

Shift, De Appel Foundation, Amsterdam. Cat.

Arte Inglese d'Oggi, Galleria Civica, Modena

Aperto '95, FRAC Languedoc-Roussillon, Conqueyrac

On Board, Riva San Biagio, Venice

Pulp Fact, Photographers' Gallery, London

Wild Walls, Stedelijk Museum, Amsterdam. Cat.

Am Rande der Malerei, Kunsthalle Bern Korean Biennale, Kwang Jung

Perfect Speed, MacDonald Stewart Art Center, Guelph, Canada; The Southern Florida Contemporary Art Museum, Tampa, Florida. Cat.

Seeing Things, Galeria Antoni Estrani, Barcelona

Biennale de Lyon

The British Art Show 4, National Touring Exhibitions; Manchester, Edinburgh and Cardiff. Cat.

1996
Looking Awry, Brazilian Embassy, Paris

By Night, Fondation Cartier pour l'Art Contemporain, Paris. Cat.

Hall of Mirrors: Art and Film, MOCA, Los Angeles; The Wexner Center for the Arts, Columbus, OH; Palazzo Delle Espozioni, Rome; Museum of Contemporary Art, Chicago. Cat.

21 Days of Darkness, Transmission Gallery, Glasgow

Traffic, CAPC Musée d'Art Contemporain, Bordeaux. Cat.

Spellbound, Hayward Gallery, London. Cat.

Sawn-Off, Uppsala Konstmuseum, Uppsala. Cat.

Controfigura, Studio Guenzani, Milan

Out of Space, Cole and Cole, Oxford

Manifesta 1, throughout Rotterdam. Cat.

Auto reverse 2, Le Magasin, Grenoble

Propositions, Musée départemental d'art contemporain de Rochechouart, Limousin

Nach Weimar, Ehemaligen Landesmuseum and Schlossmuseum, Weimar

Scream and Scream Again, Museum of Modern Art, Oxford. Cat.

Perfect, Galerie Mot & Van den Boogaard, Brussels

Host, OB projects, Amsterdam

10th Sydney Biennale

33 1/3, Canberra Contemporary Art Space, Canberra

Girls High, The Mackintosh Gallery, Glasgow School of Art and The Old Fruitmarket, Glasgow. Cat.

ID, Stedelijk Van Abbemuseum, Eindhoven. Cat.

life/live, Musée d'Art de la Ville de Paris; Centro Cultural de Belém, Lisbon. Cat.

The Turner Prize 1996, Tate Gallery, London. Cat.

1997
Material Culture: The Object in British Art in the '80s and '90s, Hayward Gallery, London

Letter and Event, Apex Art CP, New York Hiroshima Art Document

Quelques motifs de déclaration Amours, Fondation Cartier pour l'Art Contemporain, Paris

Follow Me, Britische Kunst an der Unterelbe, billboards between Buxtehude and Cuxhaven, Germany

Scream and Scream Again, Museum of Contemporary Art, Helsinki

Künstlerinnen: 50 Positionen, Kunsthaus Bregenz, Vienna

Pictura Britannica, Museum of Contemporary Art, Sydney; Art Gallery of South Australia, Adelaide; City Gallery, Wellington, New Zealand

Flexible, Museum für Gegenwartskunst, Zurich. Cat.

Goetz Collection Exhibition, Munich

Infra-slim Spaces, Soros Contemporary Art Gallery SCCA, Kiev

Southampton City Art Gallery

Animal, Centre for Contemporary Arts, Glasgow

Wish you were here too, 83 Hill Street, Glasgow

The Magic of Numbers, Staatsgalerie Stuttgart

Gothic, ICA, Boston, MA

Past, Present, Future, 47th Venice Biennale. Cat.

1998
Hugo Boss Prize, Guggenheim Museum SoHo, New York

New Art from Scotland, Museet for Samtidskunst, Oslo. Cat.

View II (curated by Neville Wakefield), Mary Boone Gallery, New York

So Far Away, So Close, Encore, Brussels Exhibition of Contemporary British Art, Japanese Museum Tour 1998–9; Tochigi Prefectural Museum of Fine Arts; Fukoka City Art Museum; Hiroshima City Museum of Contemporary Art; Tokyo Museum of Contemporary Art; Ashiya City Museum of Art and History

Secret Victorians: Contemporary Art and their 19th century Vision, National Touring Exhibition; Firstsite – The Minories Art Gallery, Colchester; Arnolfini, Bristol; Ikon Gallery, Birmingham and Middlesbrough Art Gallery, Middlesborough (1999)

1999
dAPERTutto, 48th Venice Biennale

Cinéma, Cinéma, Stedelijk Van Abbemuseum, Eindhoven. Cat.

Locally Interested, Institute of Contemporary Art, Sophia

Regarding Beauty, Hirshhorn Museum and Sculpture Garden, Washington DC; Haus der Kunst, Munich. Cat.

Notorious: Alfred Hitchcock and Contemporary Art, Museum of Modern Art, Oxford; Museum of Contemporary Art, Sydney. Cat.

Geschichten des Augenblicks / Moments in Time, Lenbachhaus Kunstbau, Munich. Cat.

Contemporary Artists at Sir John Soane's Museum, Sir John Soane's Museum, London

2000
Between Cinema and a Hard Place, Tate Modern, London

Dream Machines, National Touring Exhibition; Dundee Contemporary Arts, Dundee; Mappin Art Gallery, Sheffield; Camden Arts Centre, London. Cat.

Let's Entertain, Walker Art Center, Minneapolis. Cat.

Intelligence: New British Art, Tate Britain, London. Cat.

Mixing Memory and Desire, New Museum of Art, Lucerne

Au-delà du spectacle, Centre Georges Pompidou, Paris

Media-City Seoul 2000, Contemproary Art and Technology Biennial, Seoul. Cat.

2001
Making Time, UCLA Hammer Museum, Los Angeles

G3NY, Casey Kaplan, New York

Inaugural exhibition at the Fundación Jumex, Mexico City

Hypermental, Hamburger Kunsthalle, Hamburg

Dia Center for the Arts, New York
Dvir Gallery, Tel Aviv (with Jonathon Monk, Yossi Breger and Lawrence Weiner)
Circles °4: One for one, ZKM Centre for Art & Media Technology, Karlsruhe. Cat.
endtroducing, Villa Arson, Nice
Sean Kelly Gallery, New York
Black Box: The Dark Room in Art, Museum of Fine Arts, Berne
Douglas Gordon, J.Grigely, J.Louro, Fundació Joan Miró, Barcelona
Monitor: Volume 1, Gagosian Gallery, New York
Begijnhof IV A Kiss Is Just A Kiss, Galería Estrany – De La Mota, Barcelona
Au delà du réel, Musée départemental d'art contemporain de Rochechouart, Limousin
Switch, Musée départemental d'art contemporain de Rochechouart, Limousin
Dévoler, Institut d'art contemporain, Villeurbanne, Lyon
Notorious: Alfred Hitchcock and Contemporary Art, Hiroshima City Museum of Contemporary Art; Provinciaal Centrum Voor Beeldende Kunsten, Hasselt
Double Vision, Galerie für Zeitgenössische Kunst, Leipzig
MOVING PICTURES – Photography and Film in Contemporary Art, Esslingen
The Beauty of Intimacy: Lens and Paper, Staatliche Kunsthalle Baden-Baden, Baden-Baden
Group Show, Gallerie Nicolai Wallner, Copenhagen
Here + Now: Scottish Art 1990–2001, Dundee Contemporary Arts, and Generator Projects, Dundee. Cat.
Field Day: Sculpture from Britain, Tapei Fine Art Museum. Organized by the Taipei Fine Arts and The British Council. Cat.
Le Collège, Fonds Régional d'art Contemporain, Champagne-Ardenne
Project: Film and Video, Pittville Pump Room, UK
Loop – Alles auf Anfang, Kunsthalle der Hypo-Kulturstiftung, Munich. Cat.
Black Box Recorder: The Young Video Art From Great Britain, Bunkier Sztuki, Poland

2002 *Conversation? Recent acquisitions of the Van Abbemuseum*, Athens School of Fine Arts, Athens
Passenger: The Viewer as Participant, Astrup Fearnley Museum of Modern Art, Oslo
Silence, Crestet Centre d'Art, Crestet, France
Multiple Personalities, An Onsite/Online Group Exhibition of Artist Multiples &

Editions, Haines Gallery, San Francisco, California
Air Guitar: Art Reconsidering Rock Music, Milton Keynes Gallery; Cornerhouse, Manchester. Cat.
Hautnah: Die Sammlung Goetz, Museum Villa Stuck, Munich. Cat.
Tempo, The Museum of Modern Art, New York. Cat.
The Music in Me. Chapter I: Concerting an Exhibition, Gesellschaft für Aktuelle Kunst e.V. Bremen
To Whom It May Concern, CCAC Wattis Institute for Contemporary Art, San Francisco
Recent Acquisitions, Scottish National Portrait Gallery, Edinburgh
Sans commune mesure. Image et texte dans l'art actuel, Musée d'Art moderne de Lille Métropole, Villeneuve d'Ascq
In Dreams, Presença Galeria, Porto
Invitation, Museum für Moderne Kunst, Frankfurt am Main
Loop. Back to the Beginning, The Contemporary Arts Center, Fifth Street Space, Cincinnati, Ohio
Point of view. A Contemporary Anthology of the Moving Image, The New Museum of Contemporary Art, New York
Superstudio, Yvon Lambert, Paris
New: Recent Acquisitions of Contemporary British Art, Scottish National Gallery of Modern Art, Edinburgh. Cat.

Awards

1996 Turner Prize, London
Kunstpreis Niedersachsen, Kunstverein Hannover
1997 Premio 2000, Venice Biennale
Daad-Stipendium, Berlin
1998 Central Kunstpreis, Kölnischer Kunstverein, Cologne
Lord Provost's Award, Glasgow City Council, Glasgow
Hugo Boss Prize, Guggenheim Museum SoHo, New York

Selected Publications

1993 *Douglas Gordon*, Tramway, Glasgow 1993. Texts by Stuart Morgan and Ross Sinclair
1995 *Entr'Acte 3: Douglas Gordon*, Stedelijk Van Abbemuseum, Eindhoven 1995. Text by Selma Klein Essink
1997 *Close your eyes and open your mouth*, Museum für Gegenwartskunst, Zurich 1997. Texts by Rein Wolfs and Francis McKee
1998 *Douglas Gordon*, Kunstverein Hannover 1998. Texts by Lynne Cooke, Charles Esche,

Friedrich Meschede and Eckhard Schneider
Douglas Gordon: Kidnapping, Stedelijk Van Abbemuseum, Eindhoven 1998. Conversation between the artist and Jan Debbaut. Texts by Tom Lawson, Russell Ferguson and David Gordon
1999 *Douglas Gordon*, Centro Cultural de Belém, Lisbon 1999. Texts by Christine van Assche, Raymond Bellour and Jeremy Millar, interview by Oscar van den Boogaard.
through a looking glass, Gagosian Gallery, New York 1999. Text by Amy Taubin, screenplay by Hal Hartley
Double Vision: Stan Douglas and Douglas Gordon, Dia Center for the Arts, New York 1999. Texts by Lynne Cooke and Neville Wakefield
2000 *Déjà-vu: Questions and Answers 1992–1999* (3 vols.), Musée d'Art Moderne de la Ville de Paris, 2000. Collected interviews with the artist and texts by Harald Fricke and Elisabeth Lebovici.
Douglas Gordon: Black Spot, Tate Liverpool 2000. Mark Francis (ed.)
2001 *Douglas Gordon*, MIT Press, Cambridge MA 2001. Texts by Russell Ferguson (ed.), Michael Darling and Nancy Spector, interview by David Sylvester
2002 *Douglas Gordon: what have I done*, Hayward Gallery, London 2002

Photographic credits

Index